W9-BAR-481

BEAUTIFUL PIGS

PORTRAITS

of

FINE

BREEDS

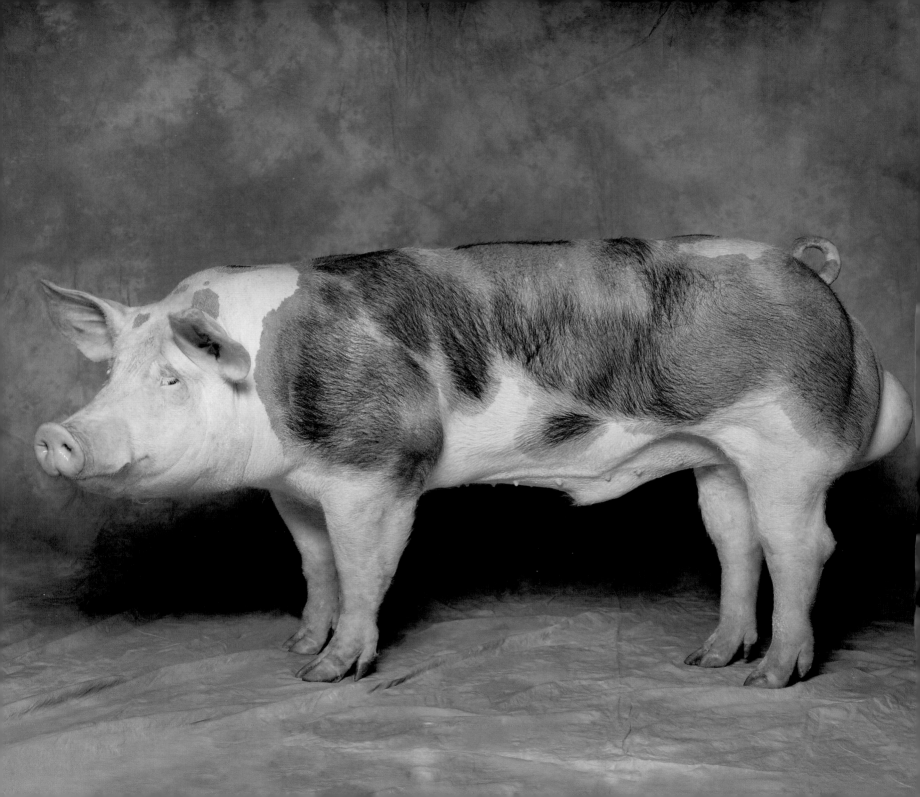

BEAUTIFUL PIGS

PORTRAITS

of

FINE

BREEDS

by ANDY CASE

photographed by ANDREW PERRIS

THOMAS DUNNE BOOKS
ST. MARTIN'S PRESS NEW YORK

THOMAS DUNNE BOOKS

An imprint of St. Martin's Press.

Copyright © 2009 Ivy Press Limited

All rights reserved. No part of this book may be used or
reproduced in any manner whatsoever without written
permission except in the case of brief quotations embodied
in critical articles or reviews. For information, address
St. Martin's Press, 175 Fifth Avenue, New York, N.Y. 10010.

www.thomasdunnebooks.com
www.stmartins.com

This book was conceived, designed, and produced by

Ivy Press
210 High Street, Lewes, East Sussex BN7 2NS, UK

Creative Director Peter Bridgewater
Publisher Jason Hook
Editorial Director Tom Kitch
Art Director Wayne Blades
Senior Editor Lorraine Turner
Designers Clare Harris, Kate Haynes, Caroline Marklew
Publishing Assistant Katie Ellis
Photographer Andrew Perris
Illustrator David Anstey

A CIP catalog record for this book is available from
the Library of Congress

ISBN 13: 978-0-312-58596-9
ISBN 10: 0-312-58596-9

First U.S. Edition: 2009
Printed in China

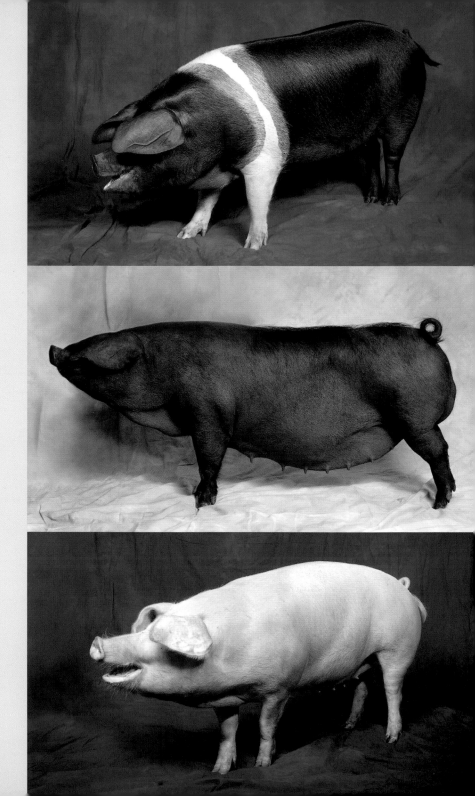

CONTENTS

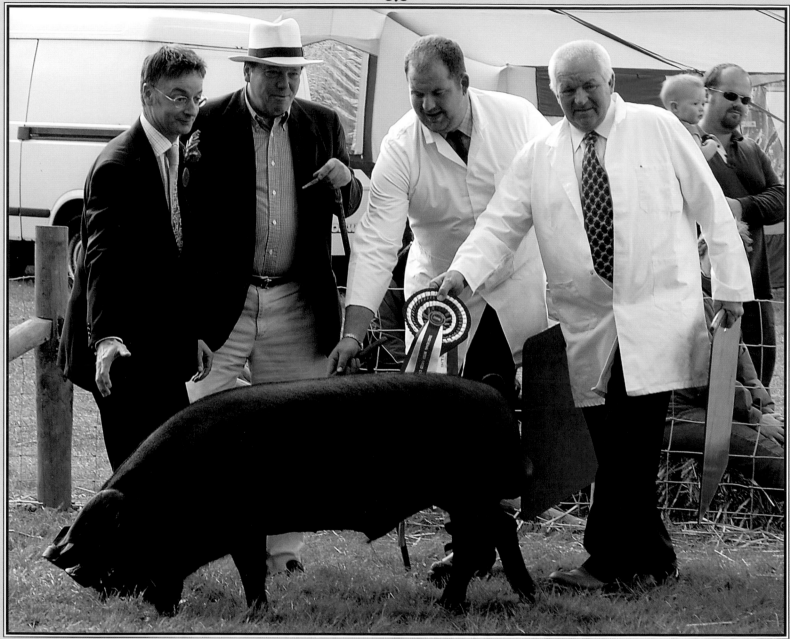

FOREWORD

IHAVE BEEN INTERESTED IN TRADITIONAL PIG BREEDS ever since my wife gave me a TAMWORTH sow for Christmas more than 20 years ago. She (the sow, not my wife) was grandly christened the "Empress of Cranborne," and ended her days in contented retirement after many years of productive motherhood.

As time went on, the Empress acquired companions. Thomasina, another TAMWORTH, graced the pig enclosures at Cranborne for many years. These two ladies were joined by other TAMWORTHS, some of them their own progeny, and by distinguished pigs from other breeds: MIDDLE WHITES and LARGE BLACKS.

The Cranborne pig enterprise thrived, and the pig population divided into two unequal parts. The first consisted of weaners, which we fattened and sold in our shop as sausages, pork, bacon, or any part of the myriad things that you make from a pig. Many weaners ran in the woods, doing good to the ground, in a modern version of medieval pannage. The second and smaller part consisted of pigs bred for the show ring and cosseted in dedicated pig paddocks. We have had a measure of success showing the three breeds at shows and have even managed to win the occasional trophy.

Encouraged by the camaraderie of the pig exhibitors, we ventured to establish our own show at Hatfield, and it is now one of the biggest pig shows in England.

The human race has not benefited from its increasing dependence on unhealthy food. Nutritionists, sociologists, and politicians have begun to understand that the quality of what we eat has a profound influence on the stability of our society and the health of the nation. The traditional breeds are the guarantors of that quality. If they flourish, we will flourish.

That does not mean that we should eat meat only from purebred Traditional pigs. All of us value the vigor that comes from crossbreeding. However, we need also to ensure that the traditional breeds exist in sufficient quality and quantity to perform their role. How should we best do that? Paradoxically, by eating them. The more demand that there is for their meat, the more breeders will respond and pig numbers will grow.

I would very much like to commend this book to you. You will see from the delightful illustrations that pigs are indeed beautiful animals. I hope this book will make all those who read it enthusiastic supporters of Traditional breed pigs and even encourage some to take up breeding as well as eating them.

Lord Salisbury
January 2009

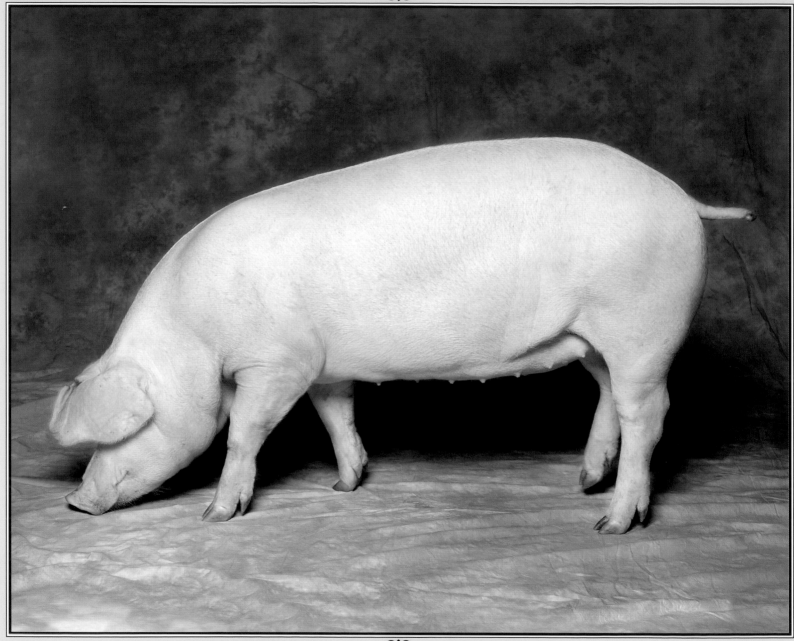

INTRODUCTION

"I like pigs. Dogs look up to us. Cats look down on us. Pigs treat us as equals".
WINSTON CHURCHILL (1874–1965), BRITISH PRIME MINISTER

HUMANS AND PIGS HAVE A STRONG AFFINITY. People smile when they see a pig—could it be that they recognize something within themselves that they share with the animal?

Like humans, pigs are intelligent creatures, yet their behavior often appears paradoxical. On occasion, when the wind blows and it pours with rain, the sow will decide to turn her arc* around to face the elements. When the human goes to feed her the next morning, the old sow is standing in the mud next to a mass of wet straw. Does this show stupidity, or had she tried and failed to do something clever?

Pigs may be stubborn, determined, and single-minded but they also have a highly developed maternal instinct. Some sows are ferociously protective and will not allow anyone or anything anywhere near their piglets. Sometimes they bark a warning but often they run straight at you.

Piglets make great demands of their mothers. During the first 24 hours, she will feed them every 20 minutes, and every hour for several days afterward. With some breeds, the sow will not get up to feed or drink for two or three days.

Despite thousands of years of domestication, the pig retains its survival instinct. It can eat almost anything with no ill effects. It is adaptable to different climates and weather and continues to live in family groups, if allowed. When a sow barks a warning, her piglets will immediately flatten themselves to the ground and freeze while the sow snorts and sniffs the air.

Pigs and piglets are very playful. A group of piglets will "dare" each other to disturb a huge sleeping boar. He'll raise his head and they will run away, only to return and repeat the game. Some may even climb on top of him, but it has never been known for a boar to hurt a piglet. Time spent in the company of pigs can be therapeutic. As any pig owner will tell you, you will walk away at peace.

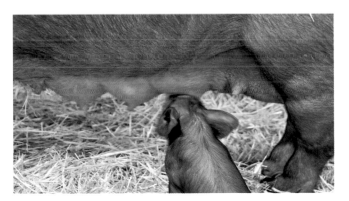

Above: Sows have a strong maternal instinct and make very protective mothers; they are always watchful for the safety of their piglets.

* See the Glossary on page 110 for an explanation of this and other breeder's terms.

PIGS IN CIVILIZATION

THE WILD BOAR (*Sus scrofa*) OF EUROPE AND ASIA was found in forests and broad-leaved woodlands, where it adapted easily to the two extremes of climate. The heavy-shouldered body was covered in brownish gray bristles, which stood up along the top of its neck and shoulders, and it held its tail straight. Ancient humans hunted this wild creature for meat. Piglets were often caught in the chase and were brought home and tamed. Later, pigs were bred from and traded for other pigs from afar, where the species had developed differently. These were then crossbred with the home species. This first occurred at around 10,000–9000 B.C.

Pigs are not suited to a nomadic existence because they are not easily herded over long distances. The first settled farmers domesticated and bred pigs in the Near East in around 8000 B.C. and in China in about 7000 B.C.; pigs were one of the first animals to be farmed. The domesticated pig spread east, south, and west to Egypt and Greece. During this period, most of western Europe was still covered in forests of broad-leaved trees, the perfect habitat for pigs. It was found that domesticated pigs thrived when confined at night and herded by day so that they could forage on acorns and beech mast.

Gradually, the wild pig changed morphologically. Its head became smaller, its nose and legs became shorter, and its body grew longer and wider. The bristled hair became finer and smoother, and the tail curled.

In the Neolithic period, the domesticated WILD BOAR of central and eastern Europe was interbred with pigs from southeastern Europe to increase the size of the animals. During Roman times, better breeding and feeding led to greatly improved specimens. The Romans cured bacon and made sausages, but this knowledge was lost with the fall of the Roman Empire and was not revived until the medieval period.

The pig was particularly important to the peasantry. Pork was often the only meat available to the rural poor. Even after World War I, it was common for rural workers to keep a pig at the rear of their yards for butchering.

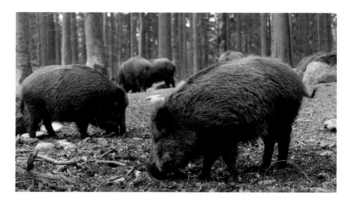

Above: Today's domesticated pigs are the descendants of the Wild Boar that thrived in the broad-leaved woodlands of ancient Europe and Asia.

DEVELOPMENT OF THE BREEDS

THE DIVERSIFICATION OF THE DOMESTIC PIG WAS, in part, determined by its local environment, which helped to develop the regional types. For instance, until the middle of the 18th century there were, broadly, two types of domestic pigs in the UK: a small, dark prick-eared pig that was mainly found in Scotland and a larger, lop-eared white or bicolored one, which lived in England and Wales. The different colors gradually arose as the color of the WILD BOAR, and striping in its piglets, ceased to be so dominant. Small, almost wild pigs foraged on the hills and moorlands. The larger breeds of pig developed in different parts of the UK into different breeds: the EAST ANGLIAN, the BERKSHIRE, and the WHITE YORKSHIRE. At this time NEAPOLITAN, CHINESE, and SIAMESE pigs were imported, which dramatically changed British native pigs. These newcomers had "dished" faces and were smaller and fatter. Native pigs were crossed with the imported species to give pig farmers the chance to breed pigs of colossal bulk (the "spherical pig").

Before Asian pigs were imported, the UK's native breeds had long, straight noses and long legs. New breeds evolved by means of husbandry and inbreeding. Traits considered undesirable in a pig were eradicated by eating the animals concerned, while specimens that conformed to the breeders' ideals were spared.

Pig breeding was not very scientific in the 18th century, and the regional types owed a lot to natural selection. It was a long process, helped by the fact that pigs produce multiple offspring and are capable of having two litters per year.

The traditional breeds raised today have, in most cases, changed a great deal. They may be smaller or larger; their ears might now be pricked, when during the 19th century they were lopped. They have certainly changed color. Tinkering with breed types did not necessarily improve vigor or the ability to survive. Natural selection became secondary to criteria imposed by humans, such as docility, mothering ability, fertility, the ability to put on fat, and hardiness.

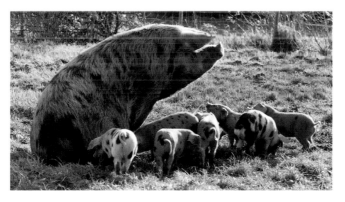

Above: An Oxford Sandy & Black sow with her piglets. One of the secrets of the pig's success is its ability to produce two litters per year.

THE BREEDS

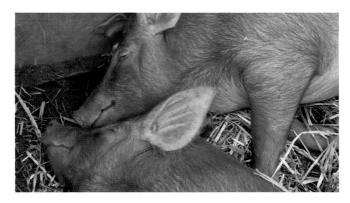

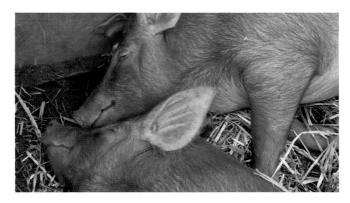

BRITISH PIGS ARE DIVIDED INTO THREE CATEGORIES: the Traditional, the Modern, and the Commercial Hybrid. The BERKSHIRE of today is a Traditional, a black prick-eared pig with white points, four white feet, and a blaze on its face and tip of its tail. In the 18th and 19th centuries, it was orange with black spots. There were other pigs that were orange and black, such as the OXFORD SANDY & BLACK. When its society was founded in 1884, it was the most famous pork pig in the land and its renowned utility spread all over the world. It had NEAPOLITAN and CHINESE blood, which gave it its dished face, early maturity and meatiness, and, early in its development, its production of fat, which was favored at the time. It was very popular, especially with the aristocracy, and even royalty.

In the north of England, it was the white pig that held sway, with breeds such as the CUMBERLAND, which was a coarse pig not as big as the YORKSHIRE, but with huge legs and flat sides; the MIDDLE WHITE, a small, white pig with dished face and short legs; the LINCOLNSHIRE CURLY COAT; and the YORKSHIRE.

Other breeds included the WELSH and, right down in the southwest corner of England, the BRITISH LOP.

The YORKSHIRE, later called the LARGE WHITE in England, is probably the most famous modern pig in the world. It has been crossed with every sort of pig imaginable around the globe. The other modern breeds include the WELSH, the LANDRACE, the DUROC, and the HAMPSHIRE.

Sadly, the CUMBERLAND and the LINCOLNSHIRE CURLY COAT are now extinct.

The most numerous of the Traditional breeds is the GLOUCESTERSHIRE OLD SPOTS, a large, docile white pig known for its three or four black spots. The BRITISH SADDLEBACK is particularly striking with its glossy black coat, divided by a white belly band from just behind its shoulder. It originated on the south coast of England and has strong maternal instincts, rearing large litters. The ponderous LARGE BLACK glistens when the sun shines on its coat, and it has a mild temperament. For a truly eye-catching pig, however, you simply can't beat the golden, long-nosed TAMWORTH.

Above: The Tamworth pig is named after the town of Tamworth in Staffordshire, England, and is one of the most attractive breeds.

BREEDS AROUND THE WORLD

THE DANISH LANDRACE HAS BEEN EXPORTED ALL over the world. The long, lean LANDRACE has very high fertility and good maternal instincts, and is one of the greatest reservoirs of genetic material for the pig world. It has achieved this status due to the exceptional diligence of the Danish breeders and testing stations where science has played a big role since 1907, keeping the quality of the Landrace pig high.

The LARGE WHITE is the leading native breed in England and Northern Ireland. LARGE WHITES are known for their large litters, their milking ability, and their strong maternal instincts. They are lean, active, and sound. As a terminal sire they are supreme; the boar stamps quality and uniformity on all his sows, wherever they are found, all over the world.

The DUROC, a prolific red pig from the eastern United States, has been exported to nearly every country in the world as a terminal sire. It is the most popular pig in the United States and its influence is highly regarded. Its red color was thought to make it hardier than black or white pigs.

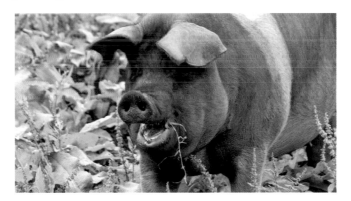

Above: The British Saddleback is the pig farmer's favorite outdoor breed. It is hardy and docile, and raises large, well-fed litters.

The TAMWORTH has been exported to all the English-speaking countries of the world. It is particularly popular in New Zealand because of the potency of its boars. It is also economical to feed, hardy, and very active.

The LARGE BLACK is a docile, prolific pig, and an exceptional milking mother. This breed is economically productive in poor situations and rough conditions. It has been exported to many countries, particularly Australia and South Africa.

The BRITISH SADDLEBACK is hardy, a docile grazer, and a good mother of large litters. Used a great deal for bacon, when crossed with the LARGE WHITE it produces the famous blue-and-white piglets that always fetch a high price at market. This pig thrives in hot climates.

The famous BERKSHIRE has a smart appearance and was patronized by royalty and the British upper classes. This breed helped to increase pig production in the United States, where it was first imported in 1841, and in Europe. It has had an enormous influence on the world's pig industry for 150 years.

EARLY YEARS

THE SHOWING OF PIGS AT AGRICULTURAL SHOWS started during the 19th century, when most of the agricultural societies were founded. They also had classes for cattle, sheep, and horses. In the old days, most stock were walked to the venue on the morning of the show or the day before. Pigs are not easy to herd any distance; they do not stay together because they do not possess the herding instinct of sheep or cattle. Pigs, therefore, were taken in some form of cart hauled by horses that were accustomed to pigs (most horses are frightened of them).

Before Christmas, fat-stock or prime-stock shows and sales were held, generally in the local livestock market, for porkers and bacon pigs, finished beef cattle, fat lambs, and sheep for mutton. All the stock were judged by experts, usually butchers, and very high prices were paid for the prize winners. Butchers hung the winning carcasses in their shop windows with their rosettes attached, to advertise the good meat they had to sell. At these Christmas fairs or sales, the smaller farmer and the laborer also sold their snare-caught rabbits.

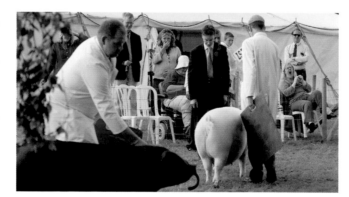

Above: At agricultural shows, pigs are judged by a panel of experts. Producing a prize winner is a source of pride and prestige.

They hung them by their back legs, threaded on a stout stick; bunches of holly were also sold.

The agricultural show is like a display window for the farmers or exhibitors and often helps to sell their breeding stock in the future because, if their porkers are successful in the show and the sale, buyers will come back for more. For exhibitors, it is an integral part of the country calendar and at the same time a social affair. Families who may not have met since the previous year often attend shows to try to beat each other with their prize sow or gilt. Despite the competitiveness over who has the best stock, agricultural shows are convivial events and there is invariably a festive atmosphere among the exhibitors in the evenings.

Agricultural shows have always been important to rural folk, providing the best yardstick by which to measure stock against that of fellow exhibitors in the ring. Novices can learn a great deal simply from good observation of the "old hands" and their pigs, and the successful breeders are usually only too pleased to help the beginner by passing on some of their experience.

SUMMER SHOWS

THERE CAN BE FEW MORE ENJOYABLE PASTIMES than showing your pigs at a summer show. Some of us also derive a great deal of pleasure from judging pigs at the shows. I was greatly honored to receive a letter from the Royal Agricultural Society of New Zealand asking me to judge the native KUNEKUNE pigs at their Royal Millennium Show, held in Hamilton. The United Kingdom also has a royal show, plus the Royal Bath and West with the Royal Cornwall, the Royal Welsh in Wales, and the Royal Highland in Scotland. Royal shows also take place in the United States, Australia, Canada, and France, all during the summer season.

These days shows often have an educational slant. There are junior classes for handlers of pigs, sheep, and cattle, and 4H clubs and stock judging competitions with similar organizations from other countries such as British Young Farmers. Here, the correct skills are learned, and they give novices a lifetime interest in producing proficient stock. These young people often go on to breed the prize-winning animals of the future.

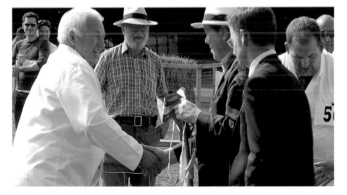

Above: Summer shows are held internationally and are an important way for young farmers to learn the tricks of their trade.

Young pig breeders attain a wonderful sense of achievement when the judge walks over with the first-prize rosette. There is and advantage for pig breeders to go to an agricultural show: it can help produce their own prize winner. The breeder can see other breeders' stock, and might decide to buy some in order to improve his or her own pigs. With skill, the new breeder can ascertain how a champion boar might overcome a fault in his sows, with his very good, straight walking action and his superior feet, the prerequisite for any show animal. It would be tragic to see an agricultural show disappear in any country; they bring the farming community together, not only by enabling them to show their best animals, but also by keeping the standard of stockmanship and welfare high. There is an exchange of ideas among farmers and stockkeepers that benefits everyone. Agricultural shows uphold rural tradition and celebrate the character of the counties, states, and countries in which they are held and the diversity of their livestock.

PREPARING FOR SHOWS

PREPARATION BEGINS A YEAR AHEAD OF THE SHOW season. Use your experience to mate your best sows with your best boar, so that the boar's bloodline and that of the sow will "nick," as some pig breeders call it. This means that these two pigs are so in tune with each other that they will always produce quality piglets. Matings must be timed so that piglets are born at two crucial times: January and July. Classes are for young pigs from the current January-born piglets and the previous July-born ones, and, of course, adult pigs.

Observation is the first task in selecting the best pigs to take to a show. Make your selection well in advance, and worm them. Be critical. Do not take pigs that walk badly; it is the first thing the judge will notice. A pig's pasterns should be upright. It should walk with a straight action. Its front feet should not turn in or out. The back ones must not brush together. Any pig that dips in behind the shoulder or slopes off sharply at the hindquarter must be left at home. In addition, your pig must have a level back.

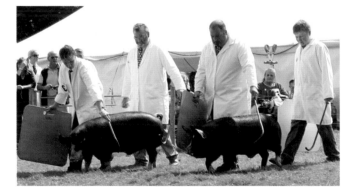

Above: In preparation for a show, black pigs such as this Hampshire breed are often brushed and oiled to enhance their appearance.

The second task is to train your pig to walk by your side, with the aid of a pig board and pig bat or stick. With a little practice, you should be able to control it. A pig that is badly behaved in the ring won't win, particularly if it upsets the other pigs and exhibitors.

Finally, it is important to wash your pigs with shampoo or soap flakes. Make sure that the inside of the ears are clean and that there are no lice eggs adhering to the hair of the pig. Rinse the pig, and dry with a towel. Pure white pigs are heaped with wood flour (extra fine sawdust) to dry them and keep them white. It is brushed off before they go into the ring. Black pigs are sometimes only brushed, then heavily oiled with a paintbrush dipped in a special oil to make their coats shine. Some colored pigs have oil lightly brushed into their coats. The TAMWORTH is never oiled.

In many countries—New Zealand, for example—the exhibitors put their pigs in the ring and let the judge move them on to see them walk. In other countries, they are judged in their pens.

WHAT THE JUDGES LOOK FOR

A GOOD JUDGE WILL WATCH THE PIGS AS THEY enter the ring. The judge will select the pig that has something special, the one with presence. After closer inspection of this one pig, all the others will follow in order. In England, exhibitors wear clean, white coats and men must wear a tie. The pigs are guided around the ring in a clockwise direction. Any handler who walks a pig in the opposite direction is putting both handler and pig at a disadvantage. This is because the judge cannot flick his or her eyes back to compare your pig against the others, and so will not be able to have a proper look at that pig. The judge must look to see if each pig has fulfilled the standards of perfection set for the breed. The pig should have prick or lop ears, long or short legs or snout; be long or shorter in the length of its back, according to the official standard, with usually 14 teats. The judge looks for a well-controlled pig that does not need to be encouraged to move along. A pig that runs from one end of the ring to the other is not being shown— it is out of control, and will be marked down accordingly. To stop a pig from running on, place your bat over its head and press back on its snout. Young January pigs are often very difficult to control, but do not run after them—they will keep running.

The judge will look for good or perfect conformation in the pigs. Most judges start from the feet up, so, if a pig cannot walk, it won't have a chance. In a ring of high-quality pigs, the decision is based on the judge's preference, with the one that first caught his or her eye usually being the first choice. Sometimes this might be controversial, but it was how the judge saw that pig on that day. The judge may receive comments from other exhibitors, mostly good-humored, if it is thought that the decision was wrong, but that's the nature of the event. At the next meeting it could be different, with the second- or third-placed pig becoming champion. Showing would certainly be a boring experience if every judge placed the same pigs in the same positions every time. It gives a breeder enormous satisfaction to win a large class with a homebred pig.

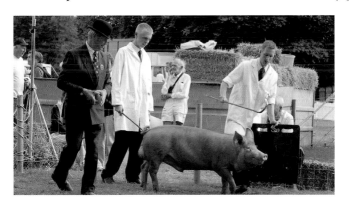

Above: Judges look for a well-behaved, well-controlled, and beautifully presented pig—but decisions can sometimes be controversial.

KEEPING PIGS

PIGS ARE SENSITIVE CREATURES. THEY NEED THE freedom to express their natural behavior, to have daylight, warmth, and bedding. They require adequate space, food, and water. Pigs kept outside need to employ their natural instincts. What is worse: to keep a pig on concrete so that it cannot root, or to have a pig outside with a ring in its nose to stop it from rooting in the earth? Pigs are gregarious and need the company of their own kind. They enjoy the sound of a caring human voice and the stroke of a hand on their backs. And for you, the joy of holding a newborn piglet is indescribable.

If you are keeping breeding stock as opposed to fattening pigs for market, it is best for them to run outside on grass. A couple of pigs can be kept in a small area, provided it is divided into two, giving you a summer paddock and a winter one. You can then reseed them in turn. It is not necessary to spend a huge amount of money to keep pigs outside. Three sheets of 6-ft. (1.8-m) corrugated galvanized iron nailed to four posts hammered into the ground, with four 8-ft. (2.4-m) sheets for the roof,

make a perfectly good house. In summer, put straw bales on the roof to keep it cool; the same layer of bales will keep your pigs warm in winter. During adverse weather, nail a piece of old carpet over the front. Pig shelters with floors are bad news; they harbor lice and rats underneath them because they provide a warm, dry environment.

When buying weaners for finishing, obtain them at eight weeks of age to take on to pork or bacon. If you want pork, do not keep them too long. Six months old is the limit, otherwise they will be too fat. When buying Traditional stock for your outdoor system, be sure to buy pigs that have been reared and kept outside to ensure that they are hardy and healthy. Ask if they have been wormed, and worm them immediately if they haven't. A weaner full of worms will not grow steadily. It will carry little flesh on its back, and will have a bloated belly and a dull, spiky coat. Do not buy weaners from a market on a drafty day, because this places undue stress on them, and make sure that you have a warm, sheltered area ready for their arrival.

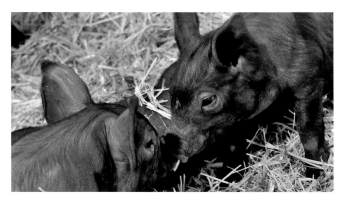

Above: Keeping pigs can be very rewarding. They are gregarious creatures and enjoy human contact, as well as the company of their own kind.

CARING FOR PIGS

PIG PADDOCKS ARE BEST MADE OF "STOCK FENCE," with the posts put in the ground 2 yds (1.8 m) apart and the wire fence strained very tightly. Breeding and boar pens must be protected with a single strand of electric fence because boars and big sows can push the unprotected fence over. Pigs in their natural state eat little and often, so provide their supplementary food twice a day, morning and afternoon, and stick to the same times every day. If you can get hold of fodder beet for the winter, give it to your pigs. It is high in energy, so it takes the place of energy-rich summer grass. The roots are sweet; pigs love them because all pigs have a sweet tooth.

The weaning of pigs should be kept simple. Wean them at eight weeks old; by then, the sow's milk will be tailing off, and the piglets will be eating a considerable amount of dry food. If a sow with her first litter is becoming very thin prematurely, make sure that you wean her litter early, at five or six weeks. Give her three weeks' rest before putting her to the boar.

It is important to know how much space is required to accommodate the various sizes of pigs. Too few in a sty is a waste of space in the winter because when it's cold they will lie very close together for warmth. A full sty will be warmer for them because they generate a considerable amount of heat. They will also make better use of their food and fatten more quickly, instead of using half of their energy just to keep warm.

Moving pigs from one place to another takes practice. Remember, all pigs have minds of their own. You have to make them stay together. There's always one that will try to push past you. Preparation before moving young piglets is essential. All small gaps should be blocked because, if a pig can put its snout through a gap, it will push until it can get through. Have all doors and gates open ready for them, and shut those where they might escape. Keep the piglets with the sow to move them along at a steady pace, and use a pig board to guide them. Let them know exactly who's boss and, in the end, they will be compliant.

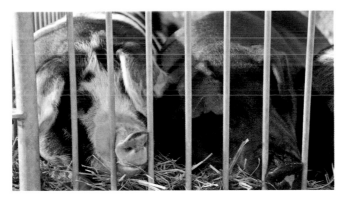

Above: Let your pigs lie close together for warmth in cold weather, and plug any gaps that a pig can put its snout through, to prevent escape.

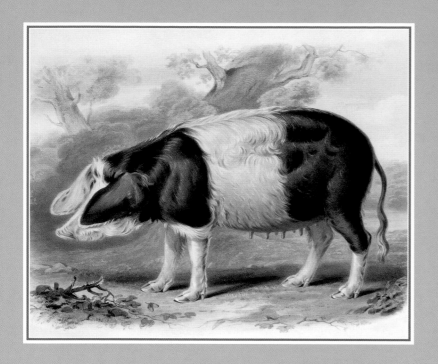

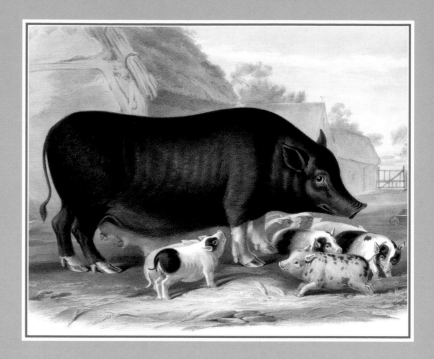

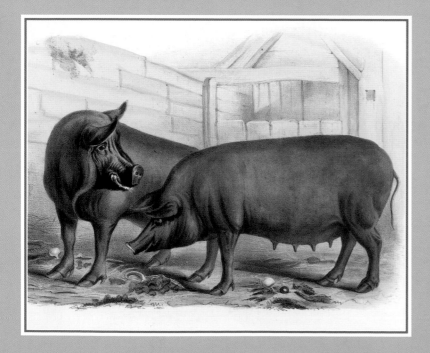

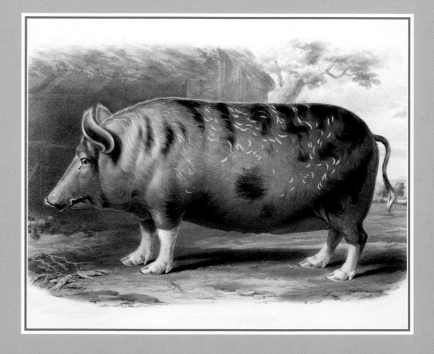

HISTORIC BREEDS

THE BREEDS in this chapter are truly the *granddaddies of them all.* Their INFLUENCE on subsequent generations of pigs can justifiably be described as "SEMINAL." Never before was *so much* owed by so many to so few. Behold the ancestors of our modern pigs *in all their original glory!*

NEAPOLITAN

The NEAPOLITAN pig from Italy was nearly always completely black. In the 15th century it was considered to be Italy's best pig and was used to produce air-cured Parma ham. It had a very fine, almost hairless skin that was wrinkled around its face. Like many other pigs of the time, it had a pair of wattles (jowls) under its jaw.

Features

The Neapolitan was a medium-size pig with strong legs, a shortish head, and short legs. It was long in the body, with good hams and a straight back. Its face was slightly dished, and it had ears that pointed forward. It was said to produce ham with the most wonderful flavor.

Size

Boar weight 272–308 lb (123–138 kg)

Sow weight 252–285 lb (114–129 kg)

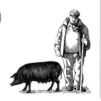

Use

In Italy, the Neapolitan was principally used for the manufacture of Parma ham. It was ideally suited for this because it matured quickly to produce a lean, meaty pig. It was also exported and used on British and many European unimproved pigs.

Related Breeds

It has been widely supposed that the Neapolitan pig had Asian blood in its veins, probably Indian, which was crossed with European types. It is also said that the Neapolitan can be traced back to the pig of Roman times.

Origin and Distribution

The Neapolitan was originally from Italy and the northern Mediterranean countries.

Italy

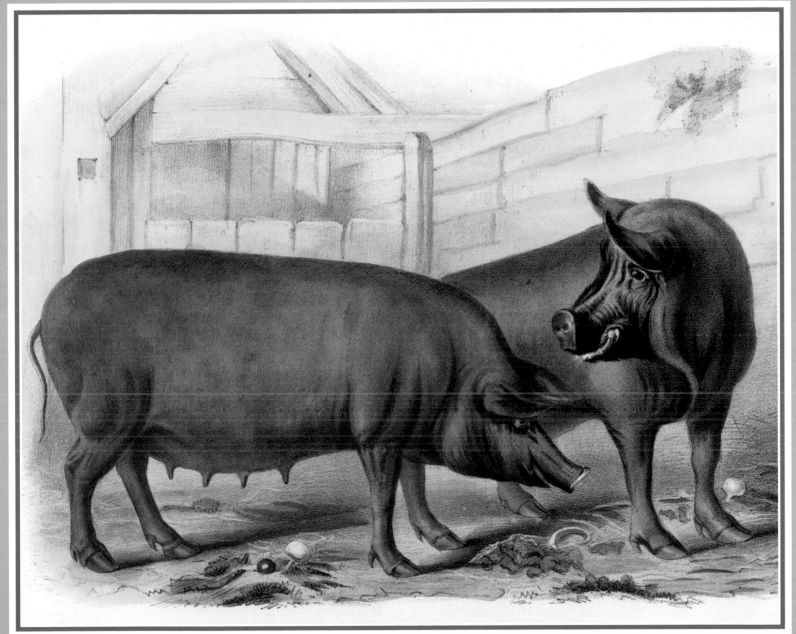

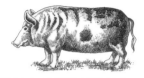

OLD BERKSHIRE

The OLD BERKSHIRE of the 18th century looked nothing like the Berkshire of today. It was not a uniform type. Some were long and some short, and its color varied from red or sandy with black patches to black and white. It had lop ears and short legs. By the 19th century, it had prick ears and was heavier boned, but the color still varied a great deal.

Features

During the 19th century, the Old Berkshire was "improved" by many breeders. Under Lord Barrington's breeding with Asian blood, it became smaller and longer with fine bones and a propensity to put on a greater amount of fat. More improvement with Neapolitan blood gave it a finer coat and made it quicker to mature. Later, the "white points" of the modern pig started to become standard, so it had four white socks and a white tail tip.

Size

Boar weight 272–308 lb (123–138 kg)

Sow weight 252–285 lb (114–129 kg)

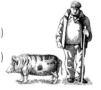

Use

The Old Berkshire was a very popular pig. With Siamese and Chinese improvements, it became lean and meaty, but because it was popular it became fashionable, and the excessively fat Berkshire was kept and prized for its size.

Related Breeds

The Neapolitan pig, which was mainly black with good hams and fine skin, was bred with the Old Berkshire. The Chinese pig provided fast maturity and fertility, while the Siamese made it smaller with better quality meat.

Origin and Distribution

The Old Berkshire was found in the East Midlands of England and spread to many other counties, except in the West Country.

East Midlands, England

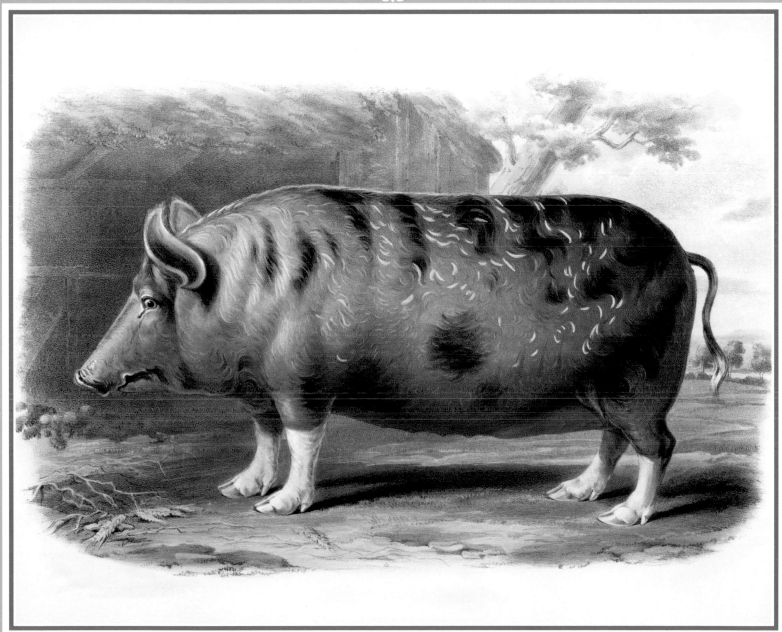

OLD ENGLISH

The OLD ENGLISH pig was common all over England in the 18th and 19th centuries, especially in woodland. It was a large, hairy animal, narrow and short in the body with thick legs. It dipped in behind the shoulders and had a slight hollow in its back. It had a long narrow head with ears that hung down, and its nose was long, which helped it to forage for food.

Features

The Old English appeared in many color combinations, depending on which part of the country it came from: red and black or all black; red and dirty yellow with spots and patches of black or red; and even some that were belted with a white band. It had no jowl under its long head, and its ears were often held forward. It had narrow, pointed shoulders and chest, with a crest along its back.

Size

Boar weight 272–308 lb (123–138 kg)

Sow weight 252–285 lb (114–129 kg)

Use

Many ran semi-wild in broad-leaved woodlands. Some were taken in by medieval peasants and housed next to their cottages. This big, coarse pig was slow to grow and survived on scraps and waste, but eventually it gained sufficient weight to be slaughtered for fat bacon and lard. It did produce some meat on its hams, but this was usually made into sausages.

Related Breeds

The Wild Boar was the basis of the Old English. The Old English was also related to the very large farmyard pigs found in Warwickshire, England, that were used for bacon, and to other colored pigs from Shropshire and Cheshire.

Origin and Distribution

The Old English was indigenous to England and widely distributed throughout the counties.

England

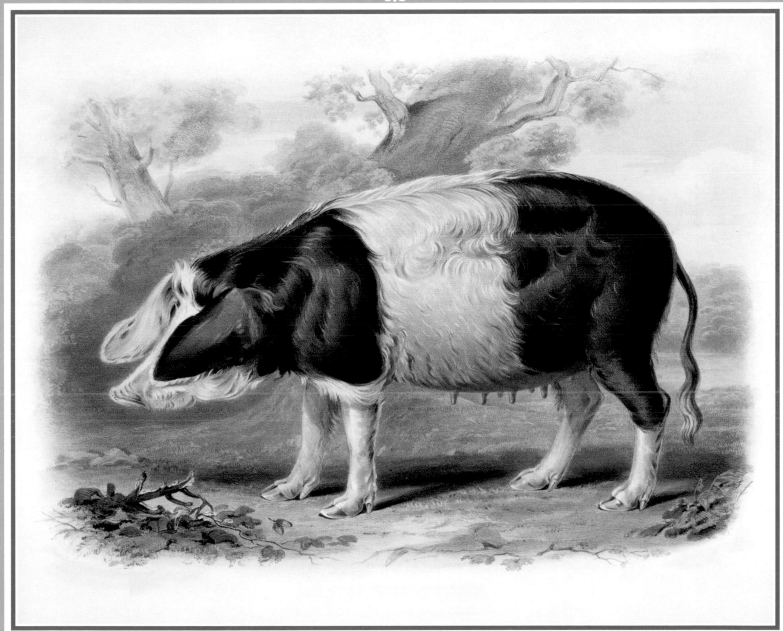

SIAMESE

These Asian pigs arrived in Britain in the 18th century. They were black, or black with white; some were slate-colored like the Neapolitan, to which they could have been related. The SIAMESE had a pleasant nature and an early maturity trait, which it readily passed on. It could tolerate extremes of hot and cold weather.

Features

The Siamese may originally have come from Vietnam. It was a docile, medium-size pig with a belly that touched the ground. It had a barrel-shape body, long with meaty shoulders, and well-developed, rounded hams. Its legs were fine-boned and short, and its ears were small and pricked on a medium-size head with a straight nose.

Size

Boar weight 272–308 lb (123–138 kg)

Sow weight 252–285 lb (114–129 kg)

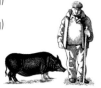

Use

This quiet, ponderous pig with its fine skin and thin, soft hair was principally used for pork. Its flesh was tender, white, and of delicious flavor. In the 18th century, the Siamese made a great improvement to the Old English and Celtic pigs of Britain, making them more prolific, smaller, finer boned, and quicker to mature.

Related Breeds

The Siamese is closely related to the Chinese pig and to those of Vietnam.

Origin and Distribution

The Siamese comes from Southeast Asia, particularly Thailand and Vietnam. It was used widely in Europe to cross with indigenous breeds.

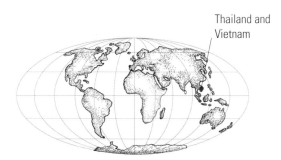

Thailand and Vietnam

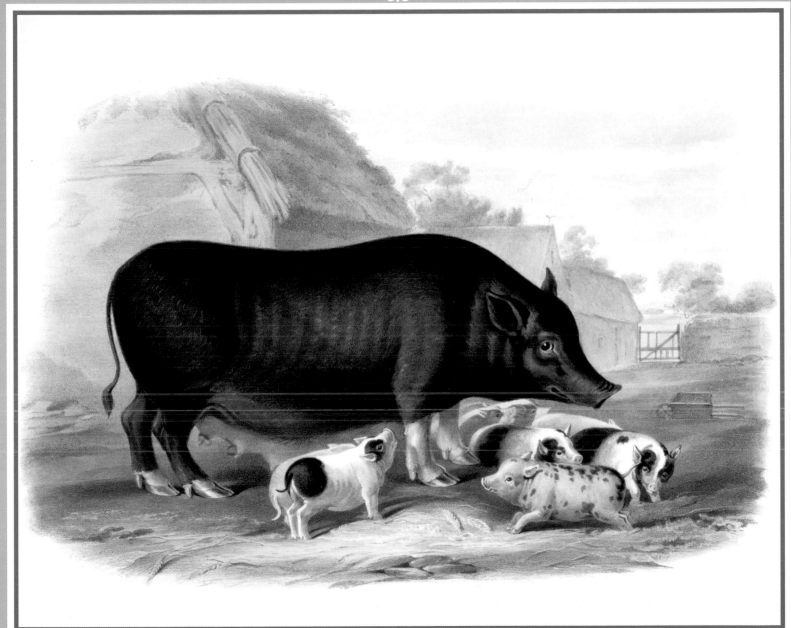

WILD BOAR

The Eurasian WILD BOAR (*Sus scrofa*) is the progenitor of all the pigs of Europe and Asia. He is of medium size with a long, almost prehensile nose and a narrow head with small upright ears. The WILD BOAR has bristled hair that can be very dense in colder, northern regions. From western Europe across to Asia, they become smaller and are of different colors. The basic grizzled color is a grayish brown.

Features

The boar is much bigger than the sow; he has enormous shoulders, which are protected by large shields of thick, solid gristle. His neck runs into a hump on top of his shoulders, with stiff upright bristles to the middle of his back. His hindquarters appear rather puny compared to his front end. He stands on massive sturdy legs, with not particularly big tusks.

Size

Boar weight 300–350 lb (136–158 kg)

Sow weight 250–285 lb (113–129 kg)

Use

Ancient humans hunted or tracked Wild Boar for meat and fur. Piglets were often captured during a hunt, and these could be tamed and fattened for meat or breeding. Wild Boar meat has no fat and is low in cholesterol. It fetches a high premium over normal pork.

Related Breeds

From the Wild Boar and its subspecies sprang all the different types of domestic pigs found in Europe and Asia, as a result of interbreeding.

Origin and Distribution

The Sus scrofa species probably originated in Southeast Asia (Philippines, Indonesia) and then dispersed across Eurasia. The Wild Boar is still found across northern Europe, the Baltic countries, and parts of Russia. It is farmed in the UK.

Philippines, Indonesia

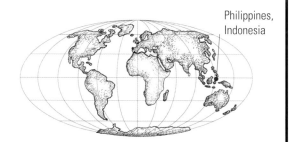

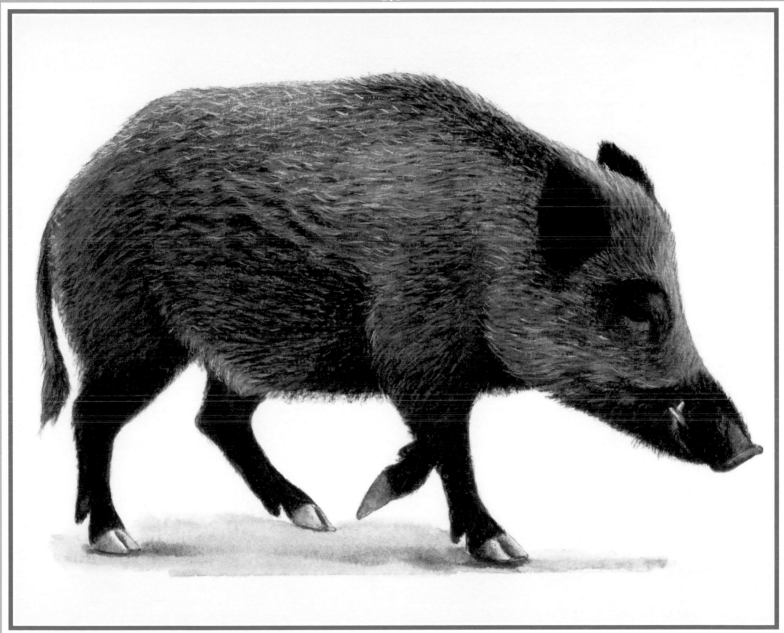

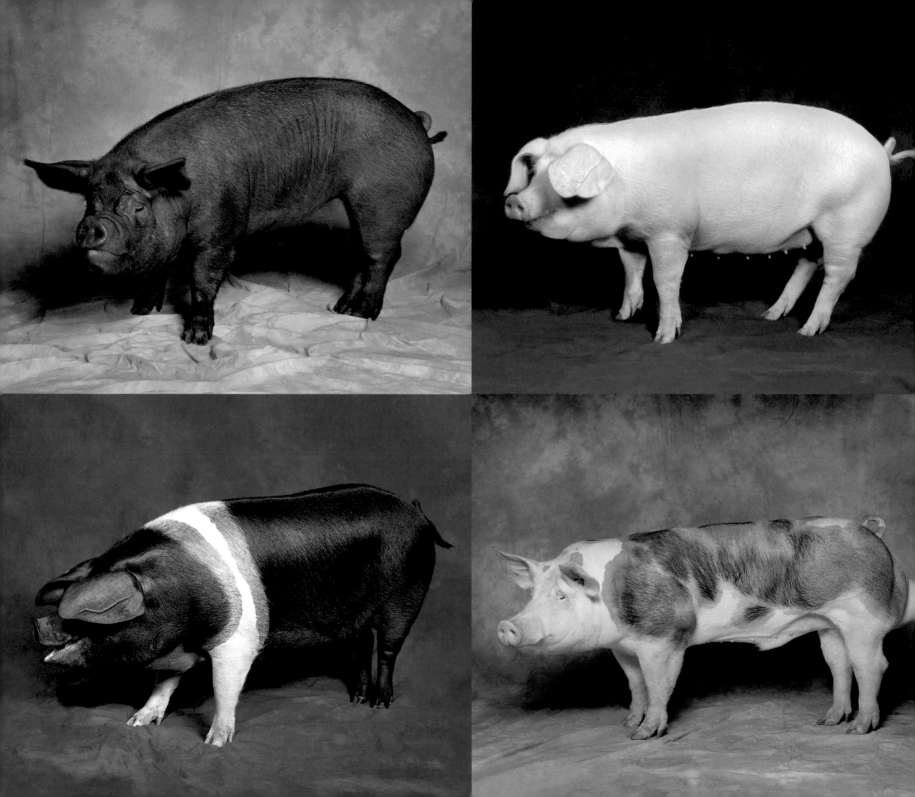

CHAMPION BREEDS

BRED *and* GROOMED to *perfection*, the pigs you are about to see are the *supermodels of the porcine universe*. Unlike their human counterparts, however, there is *no question* of skipping breakfast. These best-in-show beauties are absolutely PROUD TO BE PORKY!

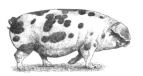

OXFORD SANDY & BLACK

SOW

The OXFORD SANDY & BLACK emerged as a distinct breed around 200 years ago. The OXFORD is a large, attractive pig, sandy to orange in color, covered with black blotches, and with four white feet and a white tip to its tail. Docile and easily managed, it was a favorite with tenants of rural cottages who had little or no land, and was known as the "Plum Pudding" pig.

Features

It is medium to large with a long, straight back and fine shoulders. The body should be deep with plenty of heart room and rounded hams. The head is slightly dished, with a medium-length nose. The ears are lopped or semi-lopped, and not too big. Oxfords are renowned for being good walkers; they have strong legs of medium length with upright pasterns.

Size

Boar weight 374–396 lb (170–180 kg)

Sow weight 340–360 lb (154–163 kg)

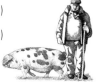

Use

Oxfords are good mothers and milk well, enabling them to rear 11 piglets easily. They are exceptional foragers and grazers. Weaned at eight weeks, piglets reach pork weight at 22 weeks of age. They lay down a lot less fat than other breeds, and so are ideal for bacon. The boars stamp all their offspring with their best genes, making the Oxford a good terminal sire.

Related Breeds

Spotted pigs have been found in Shropshire and other counties in the Midlands, UK, for more than 200 years, but the Tamworth and Berkshire breeds have helped to produce the Oxford Sandy & Black.

Origin and Distribution

From its beginnings in central England, it is now mostly found in the coastal southern counties, and has been exported only to Northern Ireland.

Central England

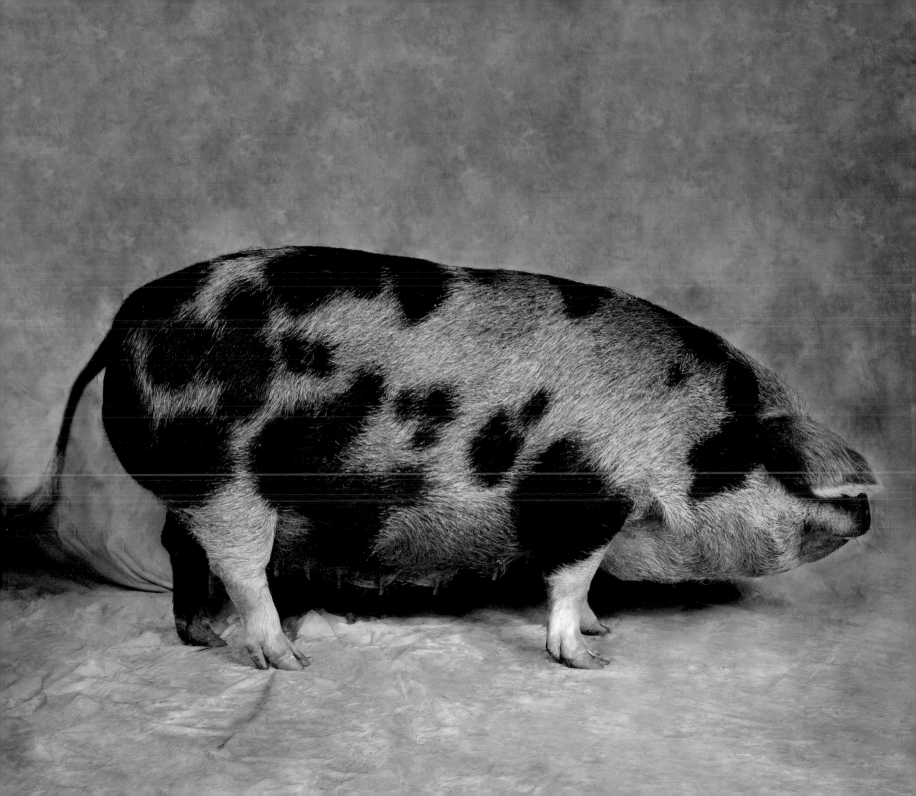

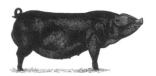

LARGE BLACK

SOW

The modern LARGE BLACK derives from two black pig varieties. One was a huge pig from Devon and Cornwall in England's southwest; the other, from the southeast, was long with shorter legs. Some were dirty white with black, and both were prolific and hardy. Neapolitan and perhaps Chinese blood are presumed to be present. The official herd book was formed about 1900.

Features

The UK's only all-black pig, it has a broad, medium-length head with long, thin lopped ears and a long, clean neck. It has fine shoulders leading to a very long, strong back and on to wide quarters and broad, full hams. It is deep-bodied with straight, fine-boned legs and strong pasterns. Its coat must be black, fine, and silky. Large Blacks are docile, extremely good mothers, and thrive on unsophisticated pig feed and grass.

Size

Boar weight 374–396 lb (170–180 kg)

Sow weight 325–350 lb (147–159 kg)

Use

The Large Black is principally a bacon pig, producing large hams. It puts on rather more fat than other breeds and, therefore, has traditionally been crossed with the Large White to produce the once popular, so-called "blue pig." The result is very succulent pork and bacon with less fat.

Related Breeds

The Large Black was said to be a cross between the enormous Devon pig and the Sussex and Kent black pigs, with Chinese to reduce the size of the original 17th-century "Old English Hog." They were improved during the 20th century.

Origin and Distribution

The Large Black was originally found in the southwest and southeast of England. Due to its black skin and adaptability it is exported to many hot countries.

Southern England

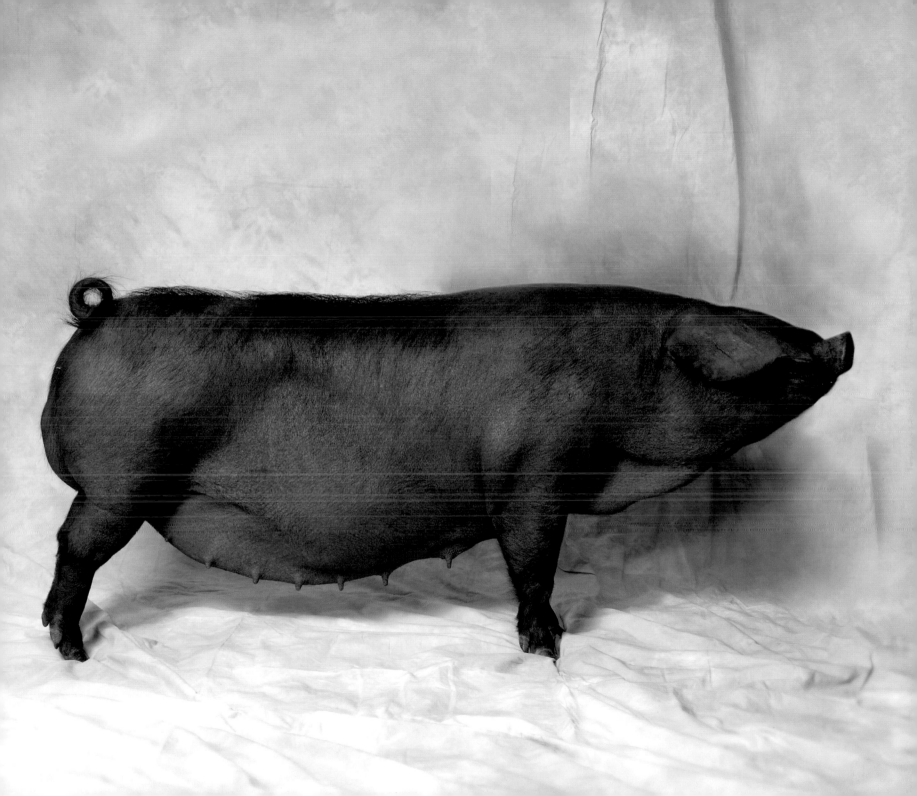

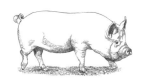

MIDDLE WHITE
SOW

The all-white MIDDLE WHITE is a sweet-natured pig, gentle and docile. It is of medium size; a heavier type, although smaller than the Large White, it has fine bones and shorter legs. Its Chinese ancestry shows in its short, dished face and snub nose and tubby appearance. It is economical to keep, but needs protection from excessive heat and sunshine, and extremes of cold in winter.

Features

It has a fairly short head, with a dished face, broad, short nose, and width between the eyes. The ears are fairly large and face outward. The thick neck is in proportion to the body and meets fine, sloping shoulders; the back is long and level with well-sprung ribs and deep, broad hams. The underline is straight and thick; legs well apart, fairly short and straight with fine bones and upright pasterns. Should give the impression of quality.

Size

Boar weight 272–308 lb (123–140 kg)

Sow weight 250–285 lb (113–129 kg)

Use

The Middle White, with its fine bones, has a good dressing percentage, meaning that there is less waste when it is butchered. It is a compact, early-maturing pig that produces small porkers in just 16 weeks—too small for most butchers these days, but between World War I and World War II, thousands were consumed in the UK.

Related Breeds

It supposedly resulted from a cross between the Large White and the Small White. More likely, it was bred down in size and type by selection. Its official herd book was formed in 1884.

Origin and Distribution

Cumberland pigs crossed with Chinese and the Yorkshire were probably the progenitors of the British Middle White. It is now widely found in Japan and Malaysia.

Cumberland, England

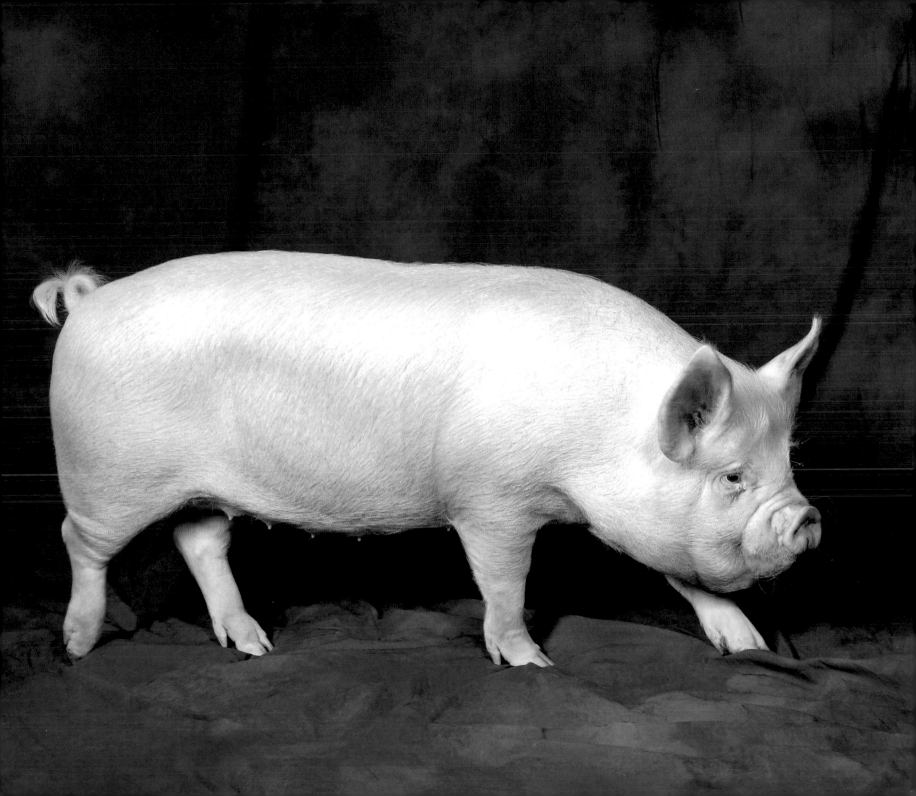

BRITISH SADDLEBACK
SOW

In the 17th century, black pigs were favored in southern England. When Neapolitan and Siamese pigs were used to improve type and succulence, then crossed with the banded New Forest pig, black-and-white pigs were produced. Some had a white belly band that went over the front legs and shoulders. Hardy, docile, and good grazers, BRITISH SADDLEBACKS make exceptional mothers. They thrive even on a poor diet.

Features

The color must be black with a continuous white belt spreading over the shoulders and including the front legs. Its has a medium-length head with clean-cut jowl and slight dish. Ears are lopped and nearly blinker the pig. The neck is clean, with no coarseness about the shoulders, and it has a long, straight back, broad loin, and medium depth of body with full hams. Legs are straight and strong with big, straight feet and a fine coat.

Size

Boar weight 374–396 lb (170–180 kg)

Sow weight 325–350 lb (147–159 kg)

Use

Used almost exclusively for bacon, this distinctive pig is often crossed with the Large White for blue-and-white bacon pigs. It has a very good food-conversion rate and its piglets grow quickly. It is found in hot countries and is easily kept behind a fence because its ears restrict its vision.

Related Breeds

The old black breeds from southwest England, mixed with those from the southeast and crossed with Neapolitan and Iberian, were mixed with Chinese to refine and improve the large indigenous black pig.

Origin and Distribution

This hardy and extremely adaptable breed has been exported all over the world from its home in England.

England

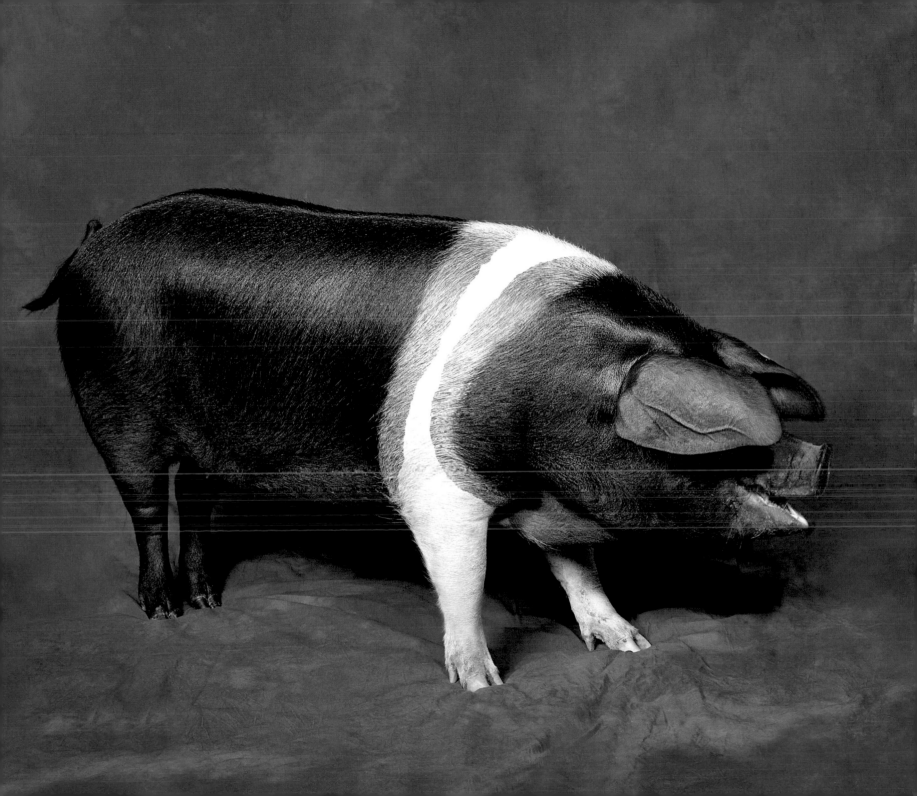

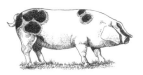

GLOUCESTERSHIRE OLD SPOTS

BOAR

The Gloucestershire Old Spots came to prominence just after World War I, after the UK's Agriculture Board started the Boar Licensing Scheme in 1913. An official herd book was formed, and hundreds were exported all over the world. They became so popular that too much poor-quality stock was used for breeding, and the breed faded drastically in number until, in 1974, it was classed as endangered.

Features

The Gloucestershire Old Spots is a large white pig with distinctive large black spots. It has a medium-long head and nose, a dished face with lopped ears, and a fine neck with small jowl and fine shoulders. A long level back should end in wide quarters and large hams. It is deep in the body with strong, straight legs. A docile grazer and hardy outdoor breeder, it was called the "orchard pig" because it was often kept in orchards.

Size

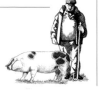

Boar weight 374-396 lb (170–180 kg)

Sow weight 325-350 lb (147–159 kg)

Use

With its large hams, the Gloucestershire Old Spots was much used as a bacon pig. It is very prolific, having large litters, and is a very good milking mother. It was often crossed with colored pigs to produce all-white offspring. The breed was very popular between World Wars I and II and many children of that generation may remember it through picture books of the time.

Related Breeds

Similar pigs were found in Staffordshire in the 18th century. Its spots may have come from the 19th-century Oxford Dairy pig, which was light colored with dark blotches. It is an old breed.

Origin and Distribution

Originally found in the West Country in the southwest of England, as well as the Midlands, it still crops up occasionally in other parts of the world.

The English West Country

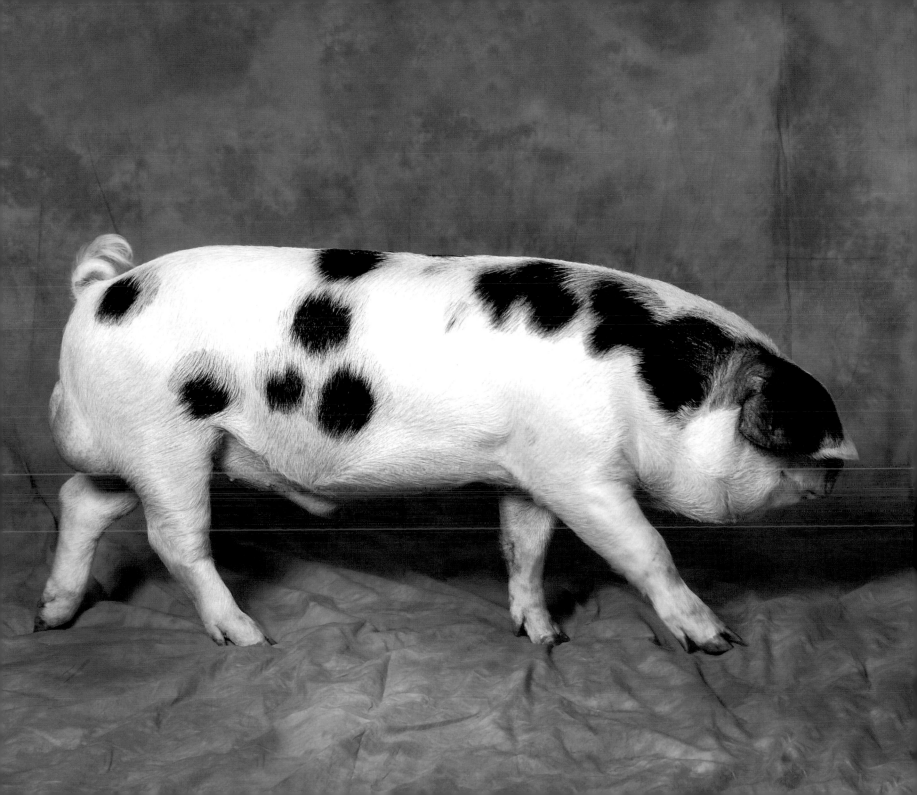

CHATO MURCIANO

SOW

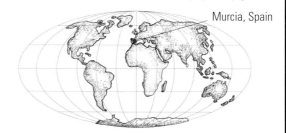

A delightful, slate-gray pig, the CHATO MURCIANO has a very old Spanish ancestry, hailing from southeastern Murcia. In 1865 there were 50,000 of them, and more than twice as many in 1929. It is thrifty, hardy, and easily managed, and does well on farm by-products and waste food; consequently it is suited to many systems of pig keeping, producing very succulent lean pork and tasty bacon.

Features

It was improved by the Large White, Berkshire, Tamworth, and the old Celtic pig from Barcelona called the Victoria. Recently, the breed was in danger of becoming extinct, but in 1999 the Spanish agricultural authorities set up a program to prevent this by artificial insemination and crossbreeding. The pig has large ears that project outward and forward. Its appearance is somewhat coarse, but it has well-fleshed hams.

Size

Boar weight 272–308 lb (123–139 kg)

Sow weight 250–285 lb (113–129 kg)

Use

The Chato Murciano produces a good yield of lean meat and excellent bacon. Recently, a great deal has been done by the Spanish to promote the excellence of its hams, sobrasada, and sausages to the markets of the world. This docile pig has come a long way and will continue to flourish.

Related Breeds

"Chato" means "short-nosed." The Chato Victoria and the British Berkshire are in the makeup of the Chato Murciano—both of these had a short nose. The Large White and Tamworth breeds do not have a short nose and were therefore selected to improve this Spanish pig.

Origin and Distribution

This breed comes from the province of Murcia in southeastern Spain. It is only recently that the Spanish authorities have helped in the development and recovery of this entirely Spanish pig.

Murcia, Spain

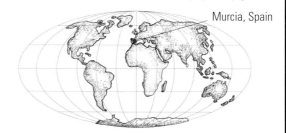

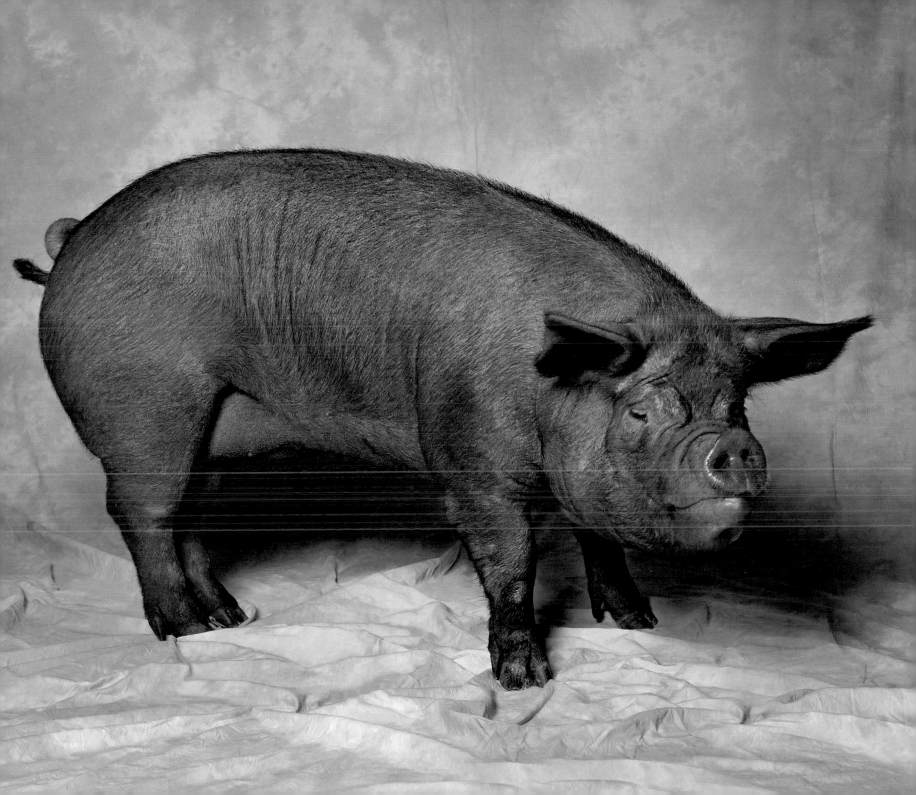

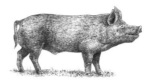

TAMWORTH

BOAR

The golden red TAMWORTH looks stunning when the sun shines on it. These are lively pigs with long legs that can "move like a racehorse." Their noses are long, and early in their long history they were known as the "Forest Pig." They make good bacon if fed carefully, even though they lack a big eye muscle of meat. The TAMWORTH is a superb outdoor pig, but not for the novice.

Features

This breed has a long head, slightly dished face and width between the ears and fine jowl. The ears are large and upright. The neck is light and evenly placed on the fine shoulders. The chest is not too deep, and the back is long and deep. The hams are well developed and wide. The legs are shapely and strong, with a good quality of bone and short pasterns. This means that the pig stands up well, with a free action and an alert look.

Size

Boar weight 374–396 lb (170–180 kg)

Sow weight 325–350 lb (147–159 kg)

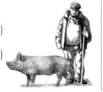

Use

An exceptional pig for outdoors, it will work well as a rotovator or as a clearer of scrub and pernicious weeds. It does not fatten quickly and needs very careful feeding in the latter stages to gain bacon weight because it will become fatty if the feed is not controlled. The bacon produced in this way is delicious.

Related Breeds

The Old Tamworth was red with black, like the Old Berkshire, but the Tamworth never had the 19th-century "improvements" of the Berkshire. Sir Robert Peel brought Irish red pigs to his Tamworth estate. Sir Francis Lawley of Tamworth kept Indian red pigs. In 1750, a red pig came from Barbados to Wiltshire.

Origin and Distribution

The Tamworth was developed in the Midlands in England, but is now uncommon in the UK. It has been exported to the United States, Canada, Australia, and New Zealand.

English Midlands

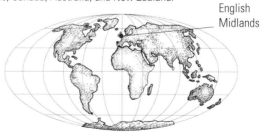

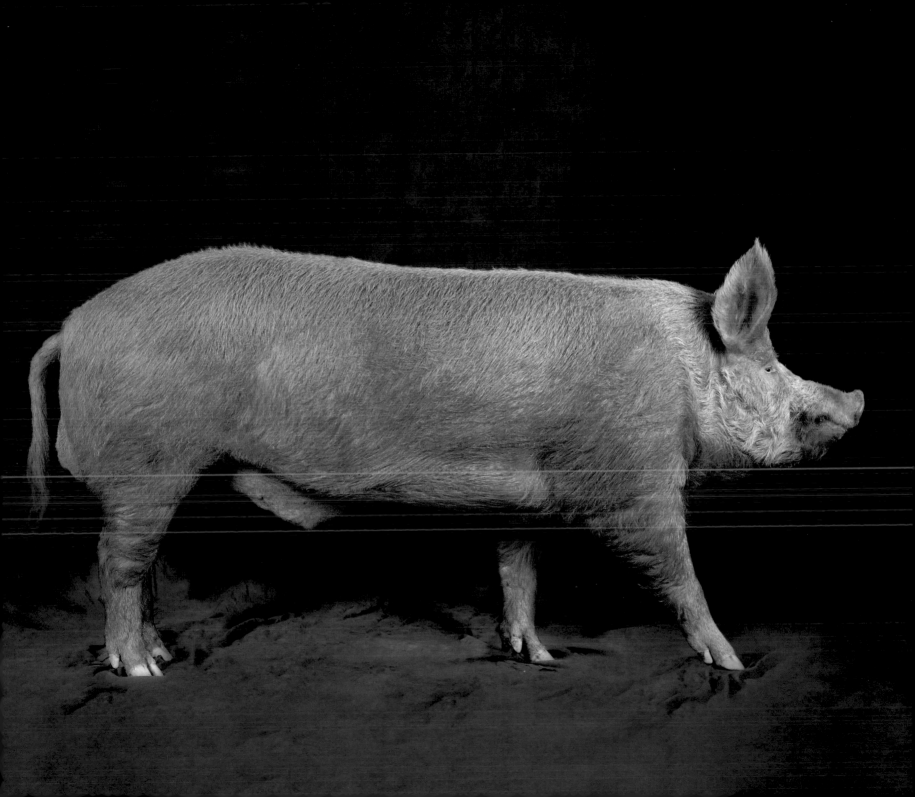

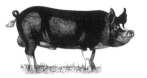

BERKSHIRE

BOAR

The Old Berkshire was a rusty color with black spots in the late 18th century. Asian blood improved the breed, and then Lord Barrington changed it from a large, lop-eared pig to a smaller, prick-eared one. The color was standardized when the breed society was formed in 1884. It then became a fashionably fat pig, but the BERKSHIRE of today is smart, medium-size, and quick-maturing.

Features

The young Berkshire is a naughty pig with a lively character. Its back is long and level, and it has a high-set tail with well-sprung ribs. Hams should be wide and deep. The head is fine and wide, with a dished face and medium-length nose. It has fine, sloping shoulders. The legs are straight, strong, and wide apart, and the Berkshire is well up on its toes, enabling it to walk well. The body is black, with some white on the face, feet, and tail tip.

Size

Boar weight 272–308 lb (123–139 kg)

Sow weight 252–282 lb (114–128 kg)

Use

The Berkshire reaches pork weight early. It is not suitable for bacon because it becomes too fat if kept longer. Its meat is famous for its quality and taste.

Related Breeds

In the 19th century, black-and-white Berkshires with large lopped ears could be found in the British counties of Devon, Norfolk, and Gloucestershire; red-and-black Berkshires with pricked ears were found in the Midlands. Chinese and Neapolitan pigs were crossed with them.

Origin and Distribution

Originally from Oxfordshire, this breed is now found all over England and Wales, and in many other countries.

Oxfordshire, England

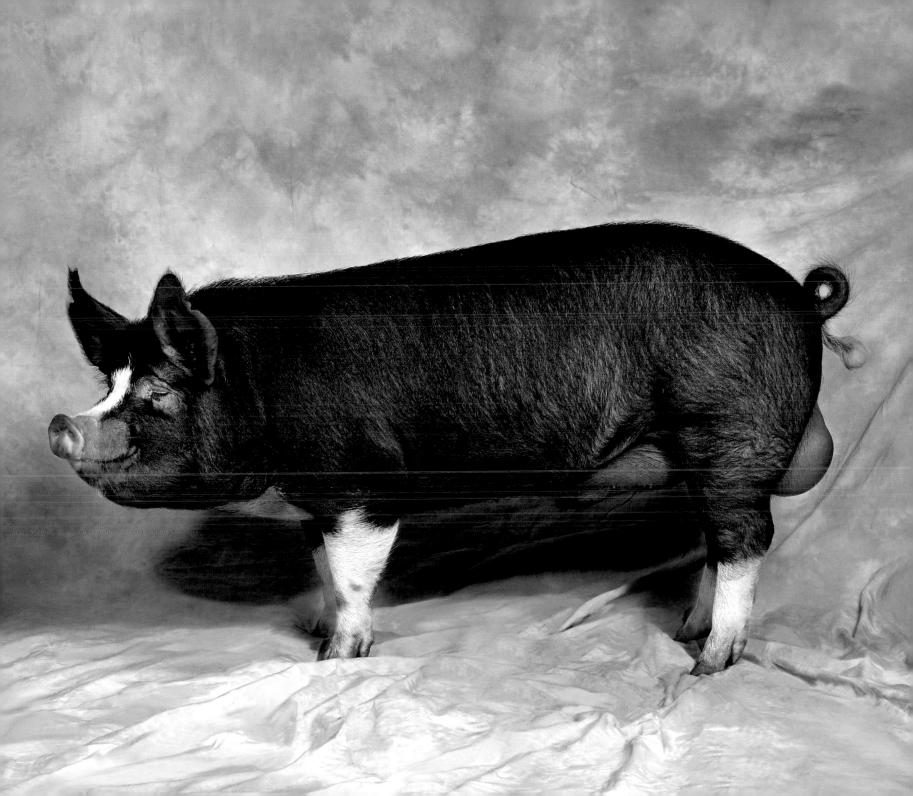

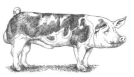

PIÉTRAIN

BOAR

The Piétrain comes from the Belgian village of the same name and was the result of crossing English and French breeds. The extraordinary genetic mutation was noticed in 1920 in the Porabant area, where it was kept. The superbly meaty Piétrain was selected by breeders and picked up by the Belgian pig industry in 1950 because of its double-muscled hams and thick, lean loins.

Features

The Piétrain is of medium size and white with blue spots, and has a medium-size, neat head. The ears are upright and slightly forward. Its short neck runs into massive shoulders, with a large, rounded deep body. The hams are double-muscled and enormous, with a sloping rump. The legs are short and strong. It measures 5 ft. 3 in. (160 cm) in length and 2 ft. 8 in. (80 cm) in height. This solid pig bulges with meat.

Size

Boar weight 570–634 lb (259–288 kg)

Sow weight 506–570 lb (230–259 kg)

Use

Before World War II, pigs were bred to be fat. Later, people wanted lean pork, so the Piétrain came into its own. It has a much higher lean-to-bone ratio than any other pig. It was exported to France and Germany, but never made much of an impression elsewhere. It has its problems: If stressed, it can drop dead, and its extraordinarily large hams and short legs mean that it cannot reproduce naturally. It is neither hardy nor vigorous.

Related Breeds

The relatives of the Belgian Piétrain are the French Normand and Bayeux, the British Large White, and perhaps the Berkshire or Tamworth. It is derived from the large, muscular pigs of the 19th century. Its official herd book was formed in 1958.

Origin and Distribution

The Piétrain is found in Belgium, France, and Germany. It has been widely exported as a terminal sire.

Piétrain, Belgium

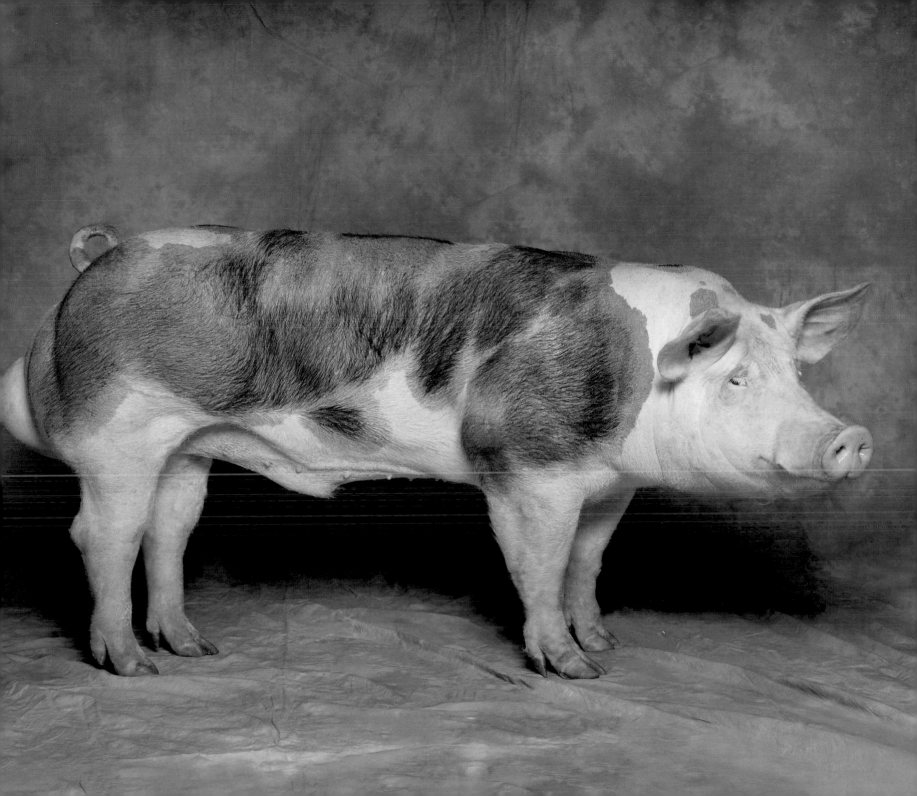

BRITISH LOP

SOW

This large, long pig came from the old, white Celtic pigs of Ireland and Wales. They are popular with farmers in the English West Country, the pigs being docile, self-sufficient, hardy, and good grazers and foragers. The BRITISH LOP produces excellent pork and bacon. The breed society was formed in 1918; they keep their own independent herd book.

Features

The pig's head should be of medium length, wide, and smooth, with long, thin ears that blinker the eyes. Its back is long and level with wide shoulders; it has a wide, strong loin and broad, deep hams. The tail is set on high. The body is deep with well-sprung ribs. Medium-length legs should be straight and level, with strong pasterns. The skin is pure white with long, silky hair.

Size

Boar weight 374–396 lb (170–180 kg)

Sow weight 325–350 lb (147–159 kg)

Use

It has a long back and is an economical feeder, making it a very good pig for Canadian-style bacon. It has a large eye muscle of meat. It does well outside, grazing and producing plenty of milk for its large litters. It is long-lived and easily managed.

Related Breeds

The British Lop is related to pigs from Northern Ireland, Wales, and Cumberland. It is suited to the small farm areas of the West Country in southwest England and is kept outside all year.

Origin and Distribution

Although found mainly in the West Country of England, there is an enclave in Warwickshire and a large herd in Berwickshire. It repays the farmer with excellent pork and bacon.

English West Country

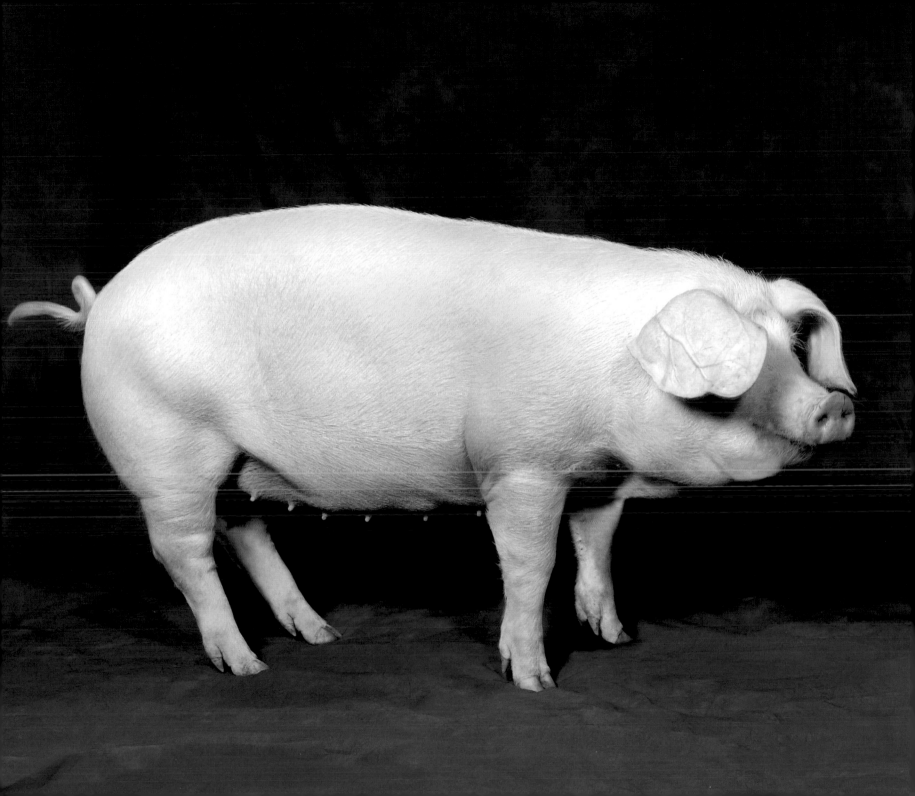

LARGE WHITE

SOW

The Large White, or Yorkshire, is probably the most popular pig in the world. Large Whites consistently have litters of 10–12 and always milk well. Butchers like them because they produce large meaty porkers and their bacon is legendary for its fine texture and flavor. In its early history, it had big lopped ears on a long head. Long in the back with flat sides, it was improved by selective breeding.

Features

The head is fairly long with a slightly dished face, and width between the eyes and large pricked ears. It has light jowl and clean neck running into full shoulders and a long, slightly arched back. Well-muscled, broad hams to the hocks. It has a strong, well-set tail and longish, straight legs with plenty of bone, set well apart. Pasterns should be short and strong, as should the feet.

Size

Boar weight 374–440 lb (170–200 kg)

Sow weight 352–374 lb (160–170 kg)

Use

The Large White makes a fantastic terminal sire and has been used on indigenous pigs in every European country and a great many others besides. A large pig, it is mainly used for Canadian-style bacon and will consistently produce meaty joints. It can be kept with equal ease outdoors or within a commercial indoor system. Both methods produce a valuable carcass.

Related Breeds

Historically, there were many farrowed white pigs in the north of England. These Old English lop-eared pigs were the progenitors of the modern Large White.

Origin and Distribution

The Large White came from the north of England, and Yorkshire in particular. It is now found all over the world.

Yorkshire, England

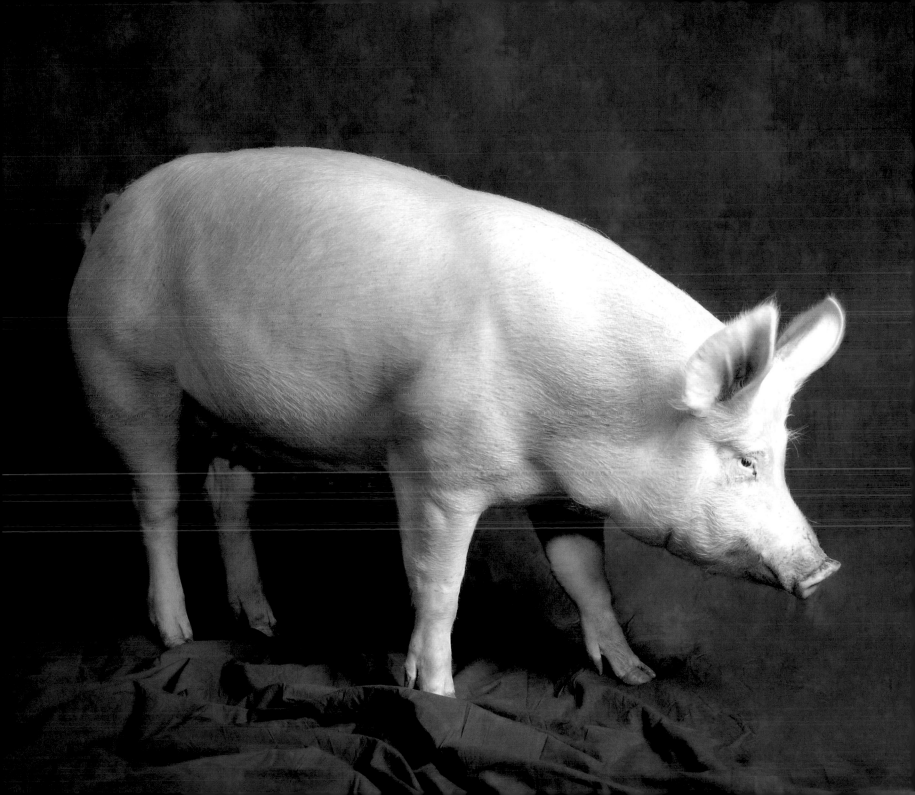

DUROC
SOW

The British DUROC was imported from the United States during the 1950s and 1960s by the large commercial pig-breeding companies to use in their breeding programs. It wasn't until the 1990s, however, that it became accepted in the UK as a pure breed. Its weight gain is phenomenal on a fairly meager diet. It is a hardy pig, which thrives outdoors during summer and winter.

Features

The most striking thing about the Duroc is its auburn color. Its head is wide and of medium size, with smallish ears bent over like a terrier's. It has a clean jowl and a wide chest; its back is wide, long, and slightly arched. The body is deep, but stands well off the ground on strong, straight legs and pasterns. It has very well-developed hams and rump, with meat to the hocks.

Size

Boar weight 310–330 lb (141–150 kg)

Sow weight 290–310 lb (132–141 kg)

Use

The Duroc is classed in the United Kingdom as a "modern breed." It makes a superb terminal sire that will improve the meatiness of all the old traditional breeds. It has fat marbling within its meat, producing the most succulent pork in hardy conditions. It is tough and always walks freely.

Related Breeds

The New York Red and the very big Jersey Red hog were cousins of the Duroc in the middle of the 19th century. Later, other red pigs were imported from England to produce this quick-growing, quiet breed, which then made it way to the UK.

Origin and Distribution

Originally from the northeastern corner of the United States, it is now found in all the pig-keeping states and in most countries around the world.

Northeastern
USA

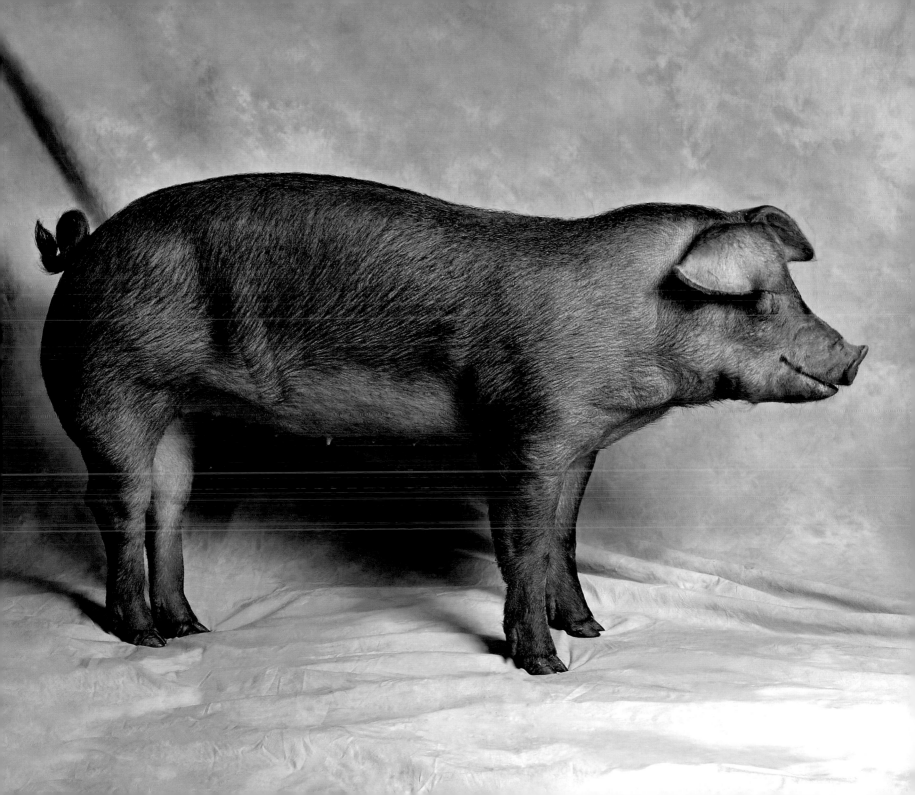

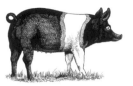

HAMPSHIRE

SOW

The HAMPSHIRE probably started its history in the New Forest in England. Black pigs with white saddles were exported to Massachusetts in around 1825, where they became known as the "Thin Rind Hog." The modern HAMPSHIRE has pricked ears and, like the Duroc, relatively little body depth. It does, however, have muscled, lean shoulders, loin, and hams. The boars can be aggressive.

Features

The Hampshire has a medium-size but wide head. The erect ears are fairly small with a clean jowl and a wide chest. The shoulders are strong and rounded at the top. The back is not very long, but is full of muscle. Rump and hams are wide, deep, and well muscled. The strong legs are of medium length, never short, with short feet and pasterns. It should walk freely.

Size

Boar weight 272–308 lb (123–139 kg)

Sow weight 252–285 lb (114–129 kg)

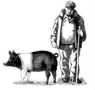

Use

One of its prime uses is as a terminal sire, and it has been widely exported for this reason. Its food-conversion rate is superb, producing a high-quality carcass with minimal fat and maximum meat and eye muscle. They are active pigs and good grazers, used almost exclusively on other American breeds for the lean-meat trade. They were imported into UK in 1968.

Related Breeds

Originally white belted black pigs from the New Forest in Hampshire, England, they were exported to the United States and selected by breeding for their lean meat, losing the lopped ears and deep body.

Origin and Distribution

From Hampshire, it spread as a terminal sire all over the United States and was exported to Europe and most of the world.

Hampshire, England

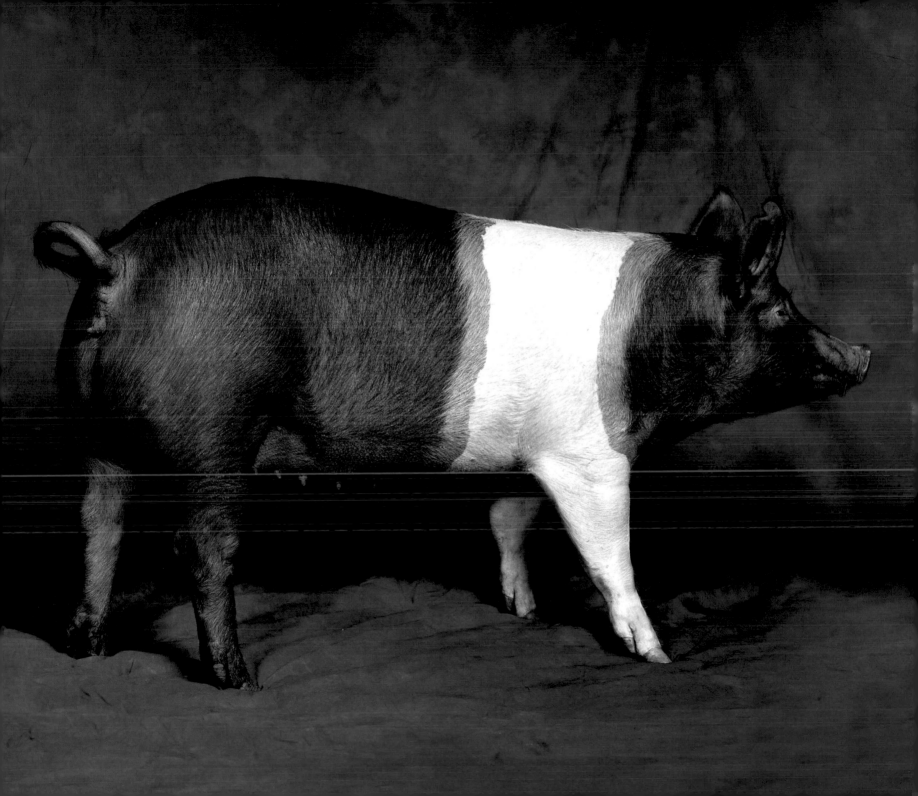

WELSH

SOW

The Welsh pig came from very unpromising beginnings indeed. It was described in the 19th century as a razorback, coarse-haired, slow-maturing type with very long legs, but the modern pig bears no resemblance to this. It has become very successful, not unlike the Landrace, but with the dished face of the Large White. Its ears are fairly long and lopped. It boasts a very long, strong back and is eminently hardy.

Features

The head should be neat, fine, and wide. The ears are lopped with a straight nose and clean jowl and neck. Its shoulders are fine and flat-topped, running into a strong, long level back, with wide meaty loins. Hams are full and firm, and the body is not too deep with a thick belly, supported on straight, strong legs with short pasterns and set well apart to walk freely. The skin and coat are fine and white.

Size

Boar weight 272–308 lb (123–139 kg)

Sow weight 250–285 lb (113–129 kg)

Use

The Welsh Pig Society was formed in 1920, and this lovely pig became popular from this date—but only, it seems, within Wales. It had all the attributes to rival the Danish Landrace, but somehow never did. It is a superb pork and bacon pig, producing large chops, legs, and very meaty, succulent hams and bacon. It is docile and gentle.

Related Breeds

Found in Wales since Viking times, it comes from the same type as the Old English Lop, large and Wild Boar–shaped. It has thrived as a result of constructive selective breeding.

Origin and Distribution

The Welsh comes from the Cardigan, Carmarthen, Pembroke, and Montgomery areas of Wales. It is not widely exported.

Wales

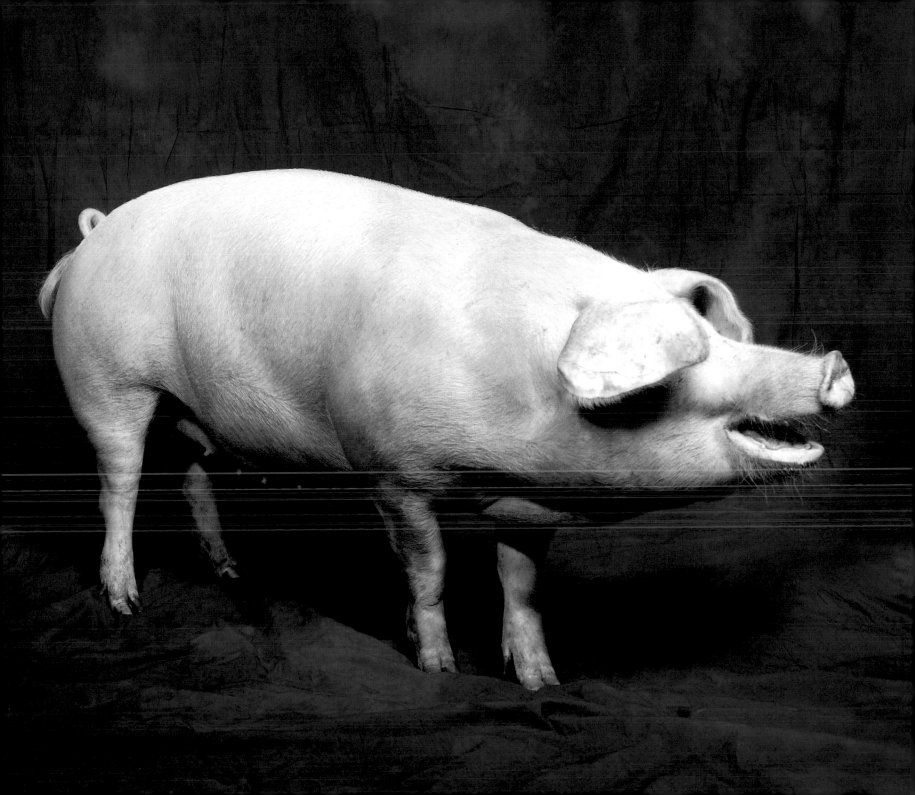

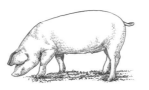

LANDRACE

SOW

The British LANDRACE is a Danish export and arrived in the UK in 1949. It is a cross between two original Celtic land pigs of Denmark, with Chinese, Iberian, and English breeds, including Middle White and Berkshire and, in the late 19th century, the Large White. The Danes were exporting bacon to the UK as early as 1860; recognizing that the Large White would influence their bacon pigs, they imported it.

Features

It has a medium-length, light head with straight nose, flopped ears, and fine jowl and shoulders. The back should be long and slightly arched, with no dip at the shoulders, leading to wide loins. The sides are not too deep, and the quarters broad and straight with full, rounded hams to the hocks. Strong, medium-length legs are well set on, with no coarseness and shortish pasterns. It has white hair over pink skin.

Size

Boar weight 374–440 lb (170–200 kg)

Sow weight 352–374 lb (160–170 kg)

Use

The productive Landrace is tailor-made for bacon, but also produces excellent pork because it is very lean. It is almost always used as the foundation of commercial hybrid pigs all over the United States and Europe. Often kept indoors, it does just as well outside, rearing large litters. Landrace sows milk well, and they are easily managed. The breed society was formed in 1953.

Related Breeds

This was the indigenous Danish pig of the 15th and 16th centuries, but was crossed with Chinese and English breeds. With careful breeding, the Landrace became a quick-maturing bacon pig.

Origin and Distribution

This long, lean meat pig from Denmark quickly became a commercial success and has influenced breeds in Europe, the United States, and the rest of the world.

Denmark

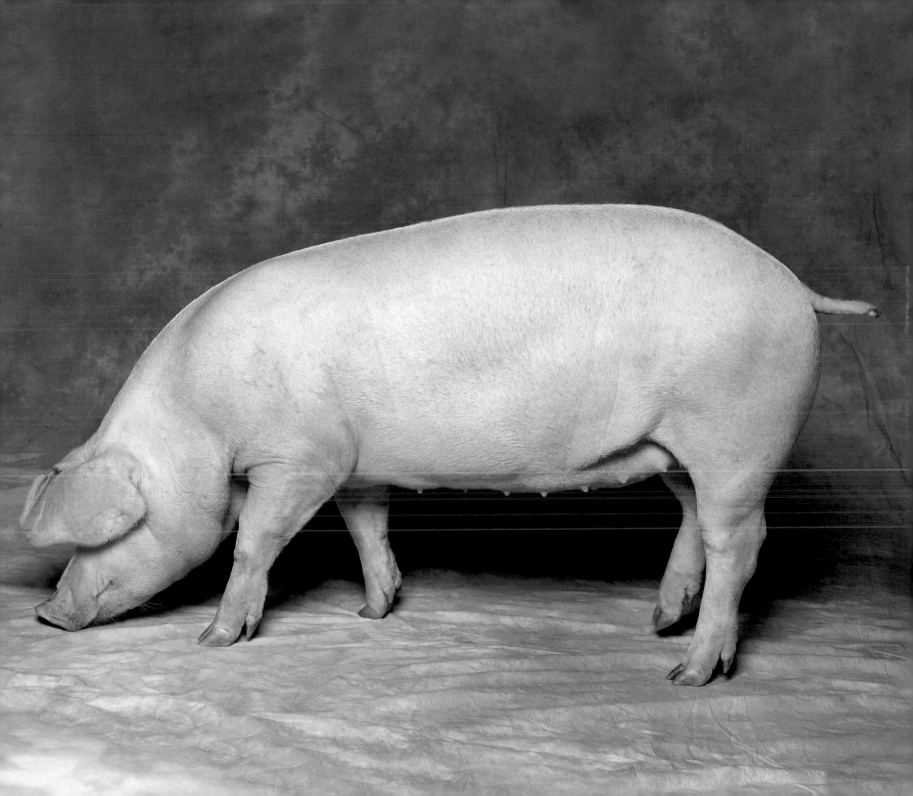

AMERICAN BERKSHIRE
SOW

The Berkshire arrived in North America from England in 1823. The early Berkshire breeders of the United States and Canada produced a smart meat pig, as opposed to the lard pigs of the time. Soon every pig farmer in North America wanted Berkshires; the breed society was formed way back in 1875. After World War II, it lost its carcass quality and fell from favor, but it is still respected. New stock was sent from England in 2005.

Features

It is a medium-size, smart black pork pig with white feet, a white tail tip, and white areas on its face. White is allowed on the body in North America, but not in the UK. It has a short dished face and pricked ears. Its body is long with well-filled hams and fine shoulders on short legs. The sow is docile, milky, and hardy. Berkshires produce sweet, lean pork.

Size

Boar weight 272–308 lb (123–139 kg)

Sow weight 250–285 lb (113–129 kg)

Use

The American Berkshire, like its English counterpart, is a fine-boned, quick-maturing pork pig. The meat is lean and succulent. It is not good for bacon, because it is too small and, if kept for long, too fat. Its food conversion is high, making it economical to keep, and, although it is black-skinned, it produces white meat.

Related Breeds

The Berkshire was the progenitor of the American, Canadian, and German Berkshire, the French Bayeux, and also the Bulgarian Dermantsi Pied, with the Spanish Murcia. Originally English, it was described in 1794 as being reddish with black blotches. By 1847, it was black and white.

Origin and Distribution

Exported to the East Coast of the United States from England in 1823, it spread all over the country as a pork pig and terminal sire. It is now found all over the world.

England

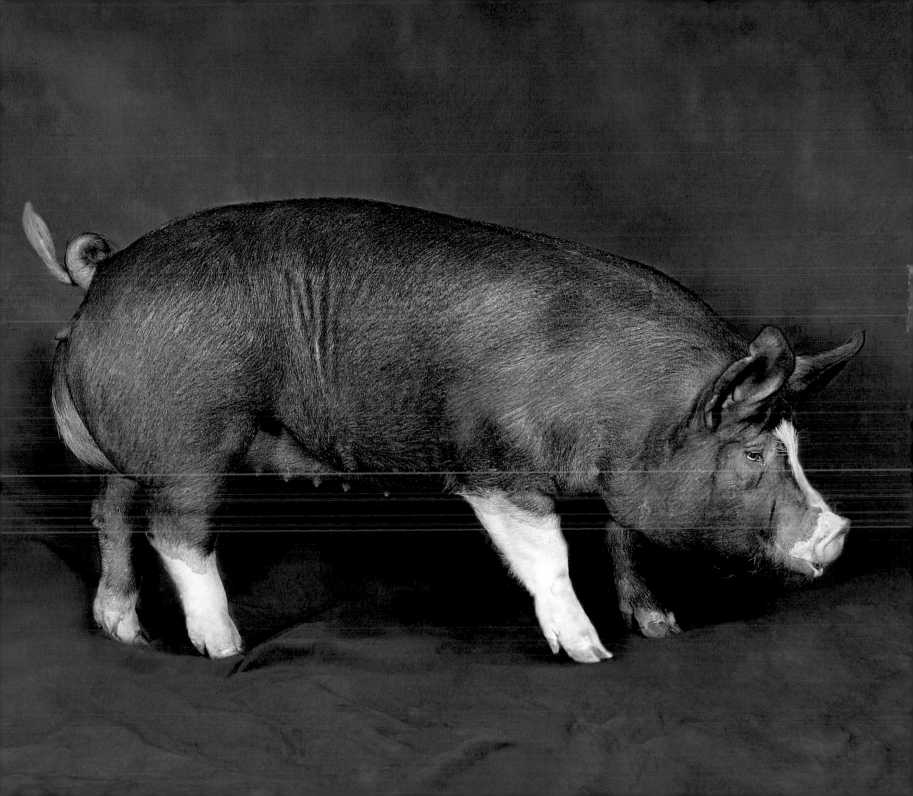

CHESTER WHITE
SOW

Nobody really knows the origin of the CHESTER WHITE, but two white pigs, the Cheshire and Yorkshire, from England, seem likely candidates. The enormous slab-sided Cheshire, coarse and long-legged, was crossed with the more refined, meatier Yorkshire, then probably mated to the American Suffolk White, which had Chinese blood and was early-maturing and fast to finish. The results were a good prolific mother and piglets that grow very large.

Features

This all-white breed originally from Chester County, Pennsylvania, is a lop-eared lean meat pig. The sows are very milky mothers of large litters. They have broad heads with short noses and dished faces. Full shoulders lead onto a long straight back and broad loins with full hams. The legs are short and strong, and the skin thin with fine hair, making it prone to sunburn.

Size

Boar weight 374–440 lb (170–200 kg)

Sow weight 352–374 lb (160–170 kg)

Use

This easily managed, large pig is suitable for both pork and bacon. It can be crossed with Yorkshire, Landrace, and also the Duroc to produce plenty of hybrid vigor. Although very prolific, it does not have very good food-conversion rate, but this modern, durable white pig yields plenty of lean meat.

Related Breeds

This reliable, hardy pig was bred in England during the 19th century from the Cheshire, Old Yorkshire, Bedfordshire, and Cumberland. Exported to the United States, it was improved through selective breeding.

Origin and Distribution

Developed in Delaware, Ohio, based on the original whites from Chester County, Pennsylvania, the Chester White became widespread in the Midwest, but is rarely seen abroad.

England

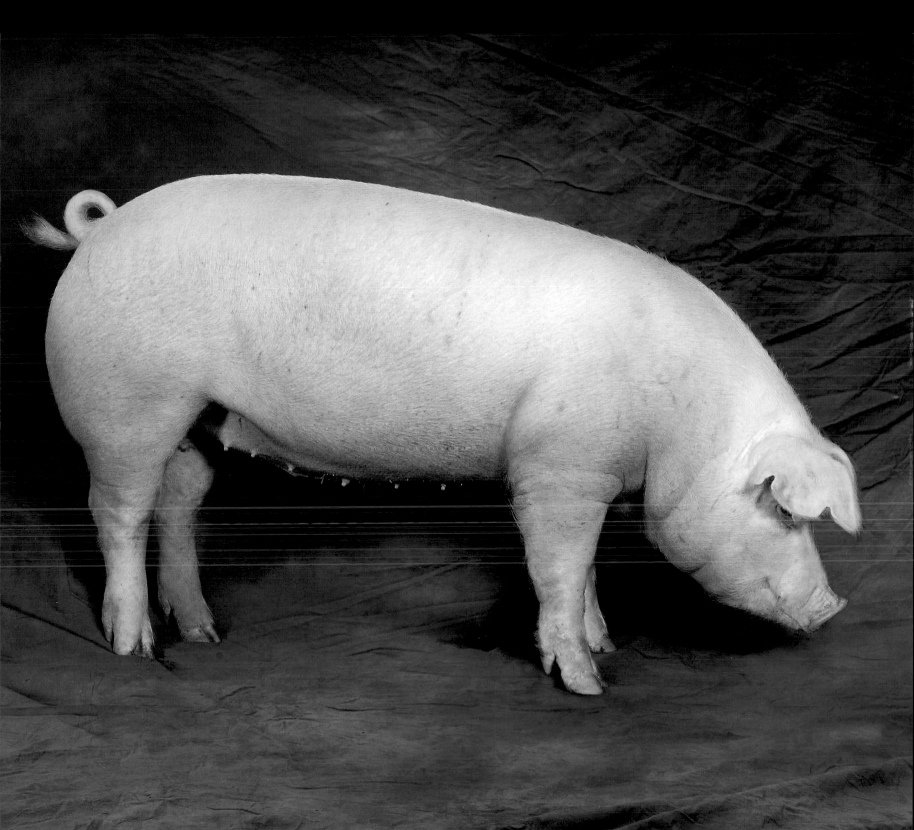

AMERICAN YORKSHIRE
SOW

In around 1870, a YORKSHIRE boar was imported to the shore of Lake Ontario from England. It was crossed with the Cheshire, also from England, to get a square-bodied large pig with big hams and shoulders. It soon became the most popular pig in the state of New York and was also much favored in Indiana, Ohio, Iowa, and Illinois, where it was prized for its low proportion of back fat and its lean meat.

Features

The Yorkshire is a large, white pig with small pricked ears, a wide dished face, and large shoulders. The broad back is arched, and the hams are big and rounded. Its legs are light and straight, with upright pasterns. The hair is silky and white over pink skin. Sows milk well, are docile, and mature early. The boars are prolific and potent, making them excellent terminal sires.

Size

Boar weight 374–396 lb (170–180 kg)

Sow weight 325–350 lb (147–159 kg)

Use

The modern Yorkshire is more muscular, with more lean meat. It is predominantly used as a bacon pig and has spread all over the United States. The sows are very fertile and have large litters that average 11 live piglets. The Yorkshire has a good dressing percentage because it has fine bones for the size of the pig.

Related Breeds

The Yorkshire has been crossed successfully with the Cheshire, the Chester White, and the Landrace, the offspring of which was often mated with a Duroc boar for a commercial hybrid.

Origin and Distribution

From New York State, the American Yorkshire spread all over the United States and the rest of the world.

New York State

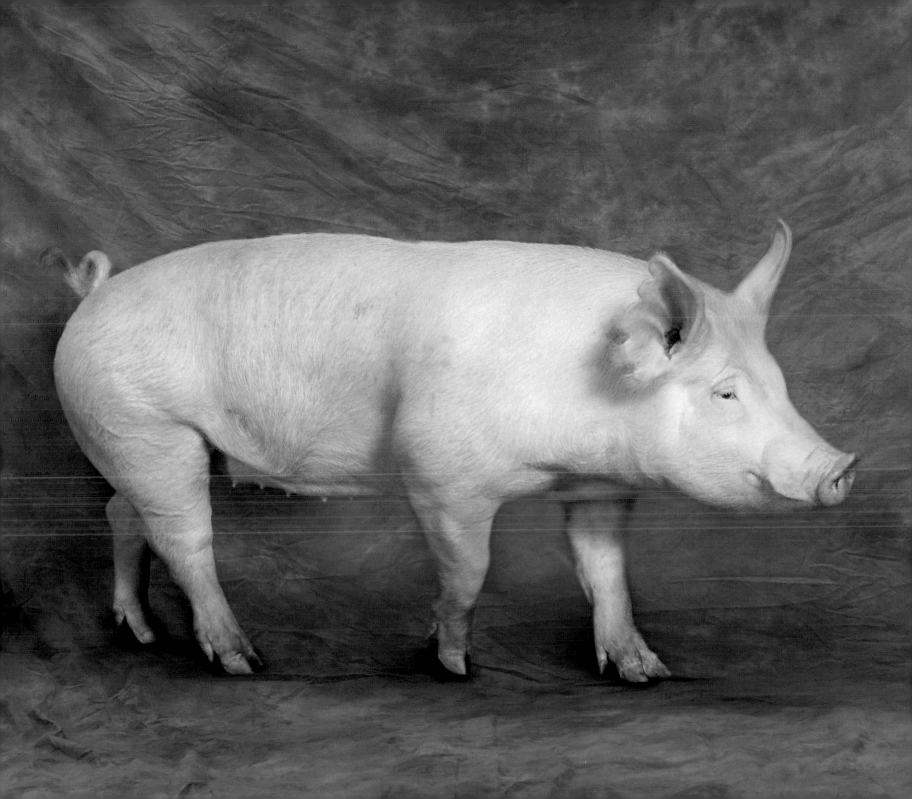

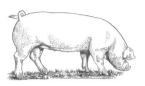

AMERICAN LANDRACE
SOW

The long-bodied, white LANDRACE pig was developed in Denmark and registered in 1906. Between 1927 and 1950 it was greatly improved and became practically the only pig kept in Denmark. It arrived in the United States in 1934, where it was crossed with indigenous breeds to improve them. Purebred or crossed with the white Yorkshire, it produced the bulk of bacon in the United States.

Features

The American Landrace is a long, all-white pig, very prolific, and easy-breeding; the boars are very potent. The sow has a long nose and large lopped ears. The loins and hams are very lean, with practically no fat. The legs are straight and strong with sound feet. It produces a carcass of superb quality from pigs that are excellent mothers and from piglets that grow exceptionally fast.

Size

Boar weight 374–396 lb (170–180 kg)

Sow weight 325–350 lb (148–159 kg)

Use

Often used as a terminal sire. The sows are used to improve other breeds because their daily live-weight gain and food-conversion rate are second to none. They are the mainstay of all European commercial hybrids. The Danish bacon industry was supported by the Landrace, and it headed the bacon industry in Canada, which exported half of all its pig meat to the United States.

Related Breeds

Apart from the American Landrace, there are Dutch, Finnish, Swedish, Norwegian, German, Polish, Czech, British, and Belgian Landrace, all derived from the original Danish. Some are more compact than the Danish pig.

Origin and Distribution

Originally developed in Denmark, the Landrace is now found all over the world.

Denmark

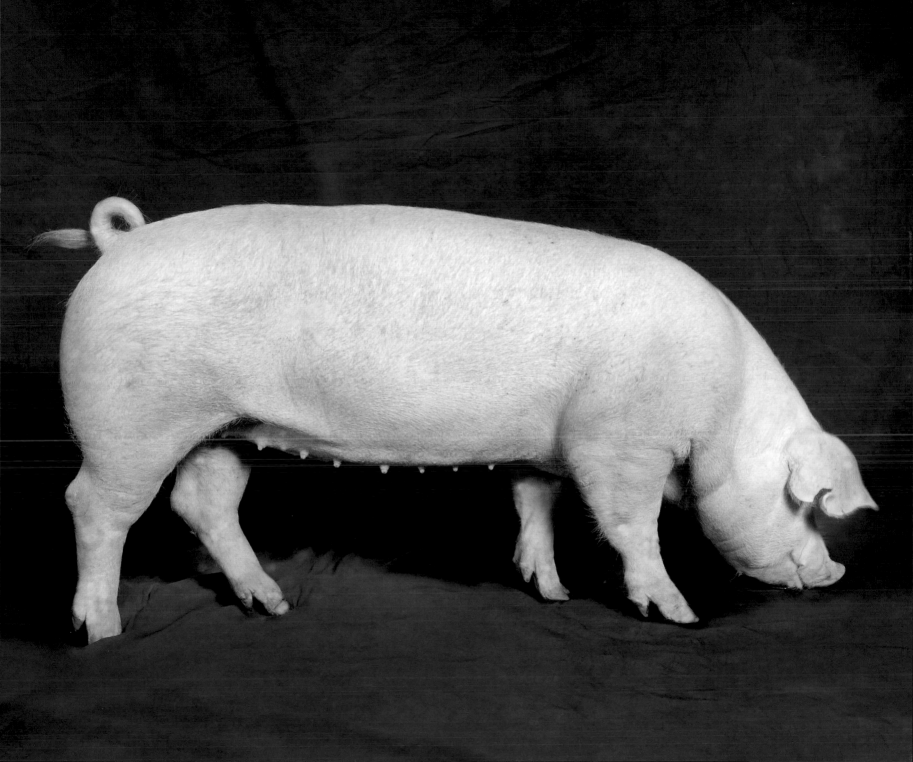

AMERICAN DUROC
SOW

The AMERICAN DUROC is smaller than the Jersey Red with a better carcass and finer frame. Isaac Frink obtained red pigs from Harry Kelsey of New York. He owned a famous trotting stallion called Duroc, and Frink named his pigs after it. The modern DUROC has an exceptional daily live-weight gain and very good food-conversion rate, making it a particularly good meat pig.

Features

The lovely American Duroc has the most beautiful dark ginger color. Its medium-sized head is wide with smallish lopped ears. Its neat neck is free of jowl, with large, meaty shoulders and well-sprung chest. The back is well muscled, and slightly arched. The body is cylindrical and supported by strong, straight legs and upright pasterns. The rump and loins are impressively meaty and well developed.

Size

Boar weight 310–330 lb (141–150 kg)

Sow weight 290–310 lb (132–141 kg)

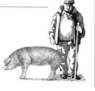

Use

The American Duroc is very popular and held in high regard. As a terminal sire it is much favored to improve the meat carcass of all the older American breeds. It produces exceptionally succulent pork because it has lines of fat within its meat. It is an active breed, healthy and prolific.

Related Breeds

The big Jersey Red and the New York Red were in the Duroc's breeding in the 19th century. In the 20th century, more red pigs were imported from England to produce a fast-maturing, easily managed hog.

Origin and Distribution

This all-American breed was developed in the northeast of America. It has now spread to the rest of the United States and to most parts of the globe.

Northeastern USA

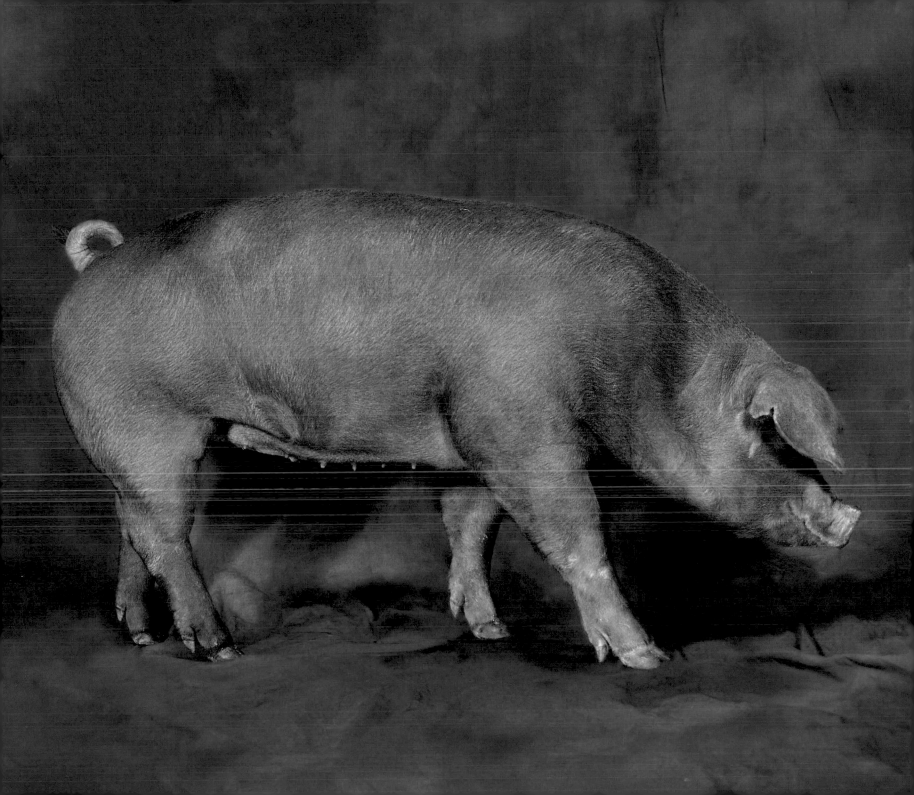

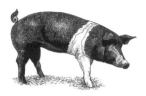

AMERICAN HAMPSHIRE
SOW

The AMERICAN HAMPSHIRE's ancestors came from England in the 19th century and were kept in the southern coastal counties of Dorset, Hampshire, and Sussex. Based in the New Forest, the breed was the result of a cross between the black New Forest pig and the Old English sheeted pig. It was later improved with Berkshire, White Suffolk, Chinese, and Essex pigs to produce the Saddleback, with large lopped ears. The HAMPSHIRE developed pricked ears.

Features

The modern black-and-white Hampshire has a longish, narrow head, upright ears, and no jowl. Large muscled shoulders blend into a barrel body with well-developed loins. The back is slightly arched, and the rump slopes down to well-rounded hams. The legs are straight and strong. It walks with a swift, active gait.

Size

Boar weight 374–396 lb (374–396 kg)

Sow weight 325–350 lb (147–159 kg)

Use

It has a good food-conversion rate and good-size litters. It is widely used as a terminal sire for the production of pork and bacon, and as an alternative to the Duroc, especially in European countries. It is a good grazer that produces a quality carcass with the minimum of back fat.

Related Breeds

In England there is the British Saddleback, an amalgam of the Wessex Saddleback and the Essex, which in turn produced the American Hampshire.

Origin and Distribution

From Hampshire, England, to Massachusetts, it spread as a terminal sire all over the United States and was then exported to Europe and most of the rest of the world.

Hampshire, England

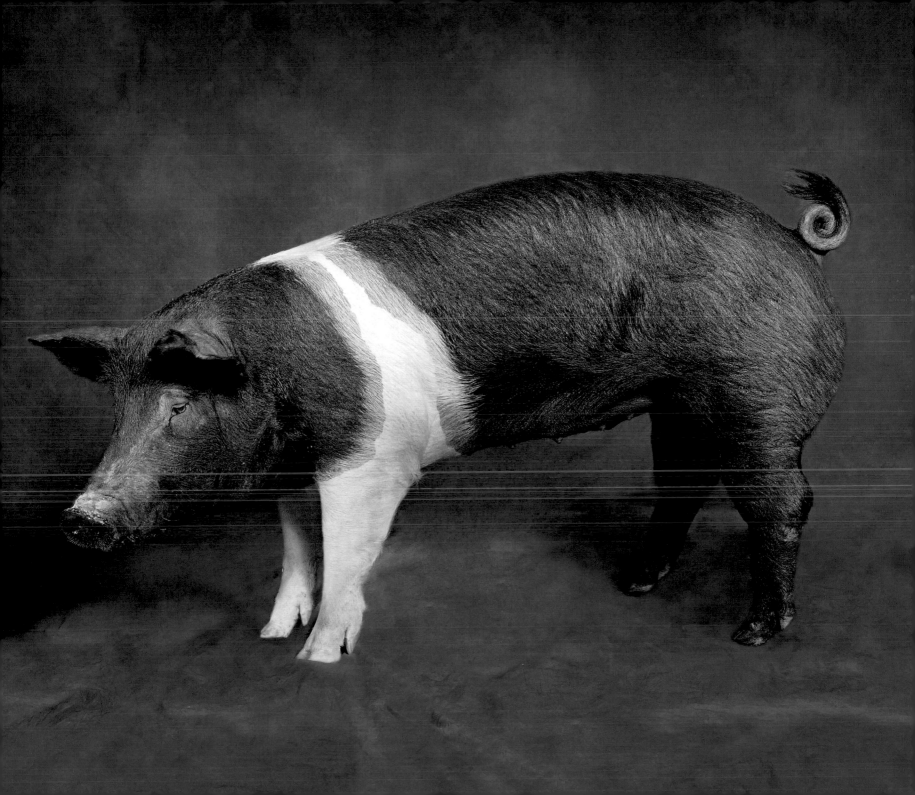

SPOTTED SWINE

SOW

This attractive black-and-white pig, big, stocky, and tough, is all-American. Based on the Poland China, it has strong Berkshire and Gloucestershire Old Spots influences. SPOTTED SWINE are thrifty, self-sufficient outdoor pigs. Sows are best left to look after themselves and their piglets. It is found mainly in Indiana. It was named as the SPOTTED SWINE—or simply Spots—in 1960.

Features

It has the overall appearance of being a rugged, coarse-haired, big-boned pig with smallish lopped ears on a moderately large head, with a medium-size snout. The shoulders are powerful, and the back long and wide with medium hams. A cylindrical body is supported by strong, thick legs. This pig is active, alert, and needs little supervision, making it popular on small farms.

Size

Boar weight 374–444 lb (170–201 kg)

Sow weight 352–374 lb (160–170 kg)

Use

Thick and muscular, this breed is not a lard pig. It produces lean meat for either pork or bacon, but rather slowly and not of the highest quality. It can subsist successfully on poor-quality rations and without a lot of care.

Related Breeds

The Spotted Swine is a mix of the Poland China (consisting of the Byfield, Russian, Big China, and Irish Grazier) and the Gloucestershire Old Spots and the Berkshire. It is not a pig for intensive farming systems.

Origin and Distribution

The Spotted Swine is a major breed, but not widespread in the United States. It is found mainly in Indiana and suits the needs of the small pig farmers there.

Indiana

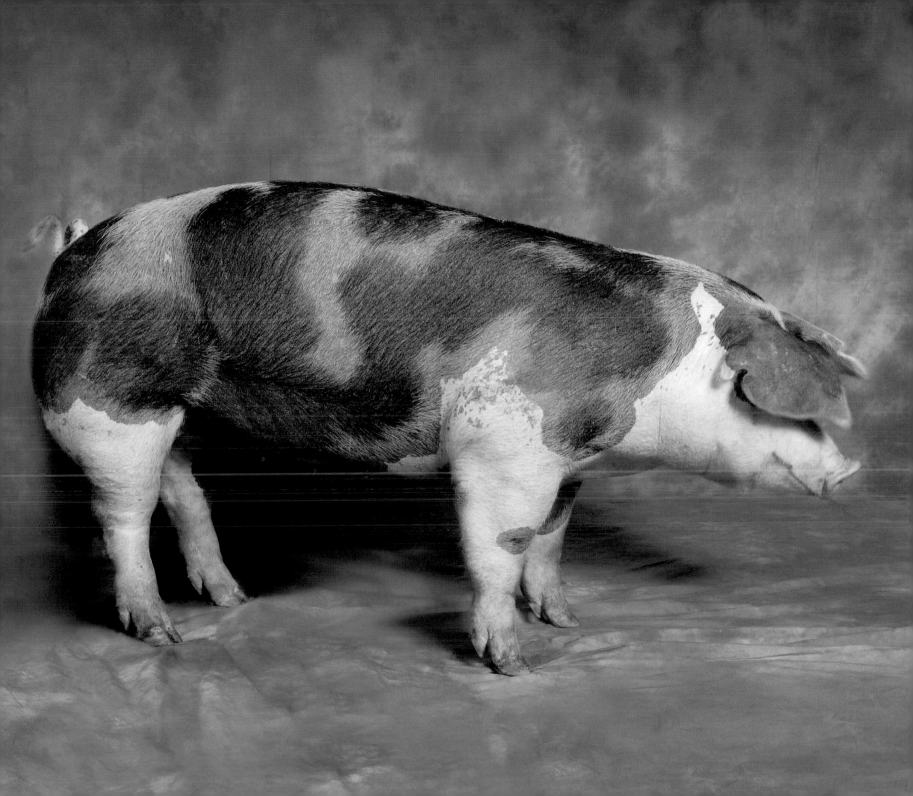

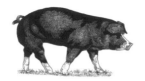

POLAND CHINA
SOW

In 1816, some Big China pigs were taken from Philadelphia to Warren County, Ohio, to improve the indigenous pigs there. The Irish Grazier pig, with its full hams and loins, was bred with Warren County pigs, and by 1860 the result was the famous POLAND CHINA, a very large, long-backed coarse pig. The modern POLAND CHINA has become one of the best lean meat pigs.

Features

This pig's coloring resembles that of a Berkshire—black with white points. Byfield, Big China, Russian, and Irish Grazier are in its makeup. It had an official herd book in 1878. It used to be the most popular lard pig in the United States. It is hardy, prolific, self-sufficient, and best kept outside.

Size

Boar weight 374–440 lb (170–200 kg)

Sow weight 352–374 lb (160–170 kg)

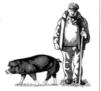

Use

For most of its history, the impressive Poland China has been kept as a lard pig, although now it is famed for its meatiness. It is a very good mother and will look after its piglets without interference. The piglets are not as fast-growing as the Durocs or the Hampshires, but some say that the Poland China's pork and bacon cannot be beaten on taste.

Related Breeds

The Poland China is so-called because it was bred by a Polish-born farmer from southwest Ohio. The pig had many nicknames, but was eventually called Poland China in 1946. Four white breeds were its base, bred to the Berkshire.

Origin

Originally developed in Warren County, Ohio, the Poland China is now widespread across the United States.

Ohio

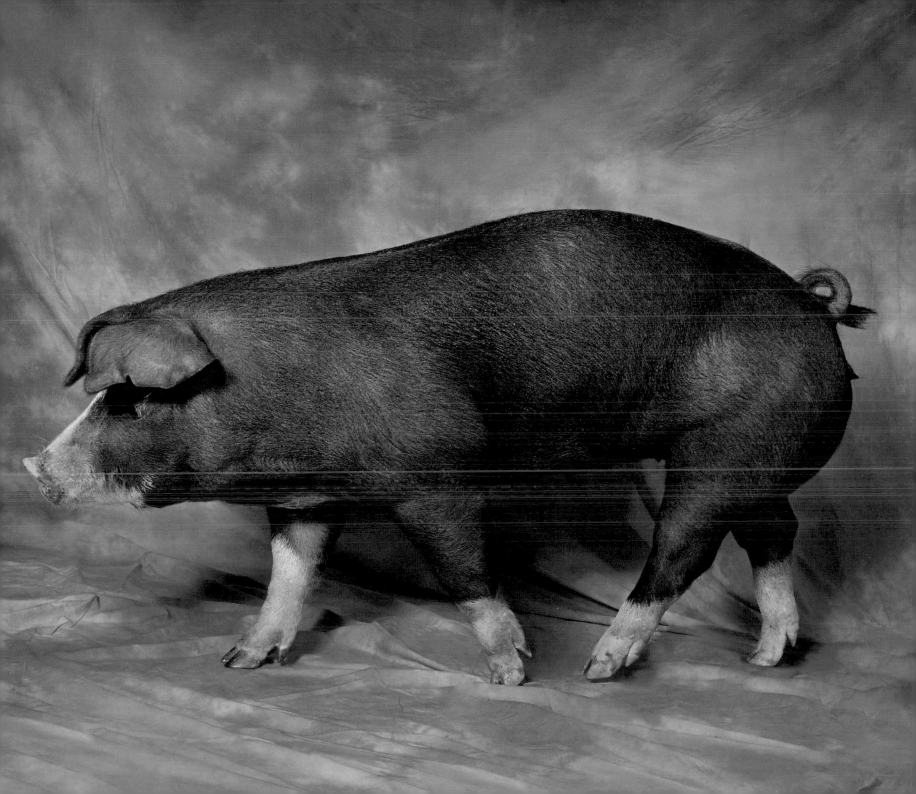

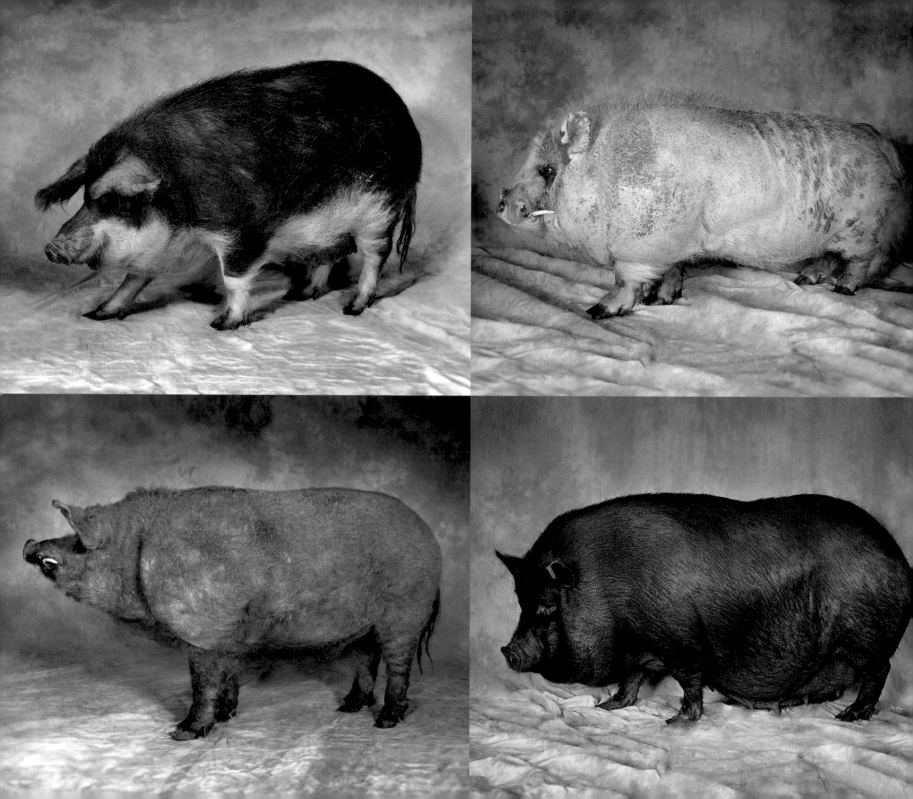

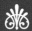

EXOTIC BREEDS

CAREFUL cultivation and cross-breeding have produced some *breathtakingly* butch boars and *simply startling* sows. For the TRUE CONNOISSEUR and those with a taste for the unusual, we are proud to present the *finest specimens* from across the globe.

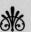

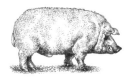

BLONDE MANGALITSA

BOAR

The BLONDE MANGALITSA is used as a lard pig in its native Hungary. Their meat animals were small primitive types found in Yugoslavia, Romania, and Bulgaria, as well as Hungary and Austria. The small MANGALITSA had its origins in Serbia, where southern pigs were crossed with Carpathian breeds to produce a lard pig. It is covered in thick, curly hair and, from a distance, looks like a sheep.

Features

The Mangalitsa's head is of medium length and devoid of wool, with lopped ears and a longish nose. The body should be deep and long, with a large belly. The short legs are straight and strong, free of wool, with black hooves. They are good grazers and do well on poor feed. The body has dense, curly hair, which protects it from heat and cold.

Size

Boar weight 272–308 lb (123–139 kg)

Sow weight 352–374 lb (160–170 kg)

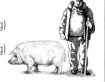

Use

The Mangalitsa is a lard pig. It is late-maturing, developing at around 15 months old. It has very small litters of only three to seven, but is exceptionally hardy and disease-free. Its lard is used for cooking and in the making of salami. The fat bacon it produces was once a staple of the diet of Hungarian workers.

Related Breeds

Originally the Serbian Sumadija and Siska were developed with Balkan, Romanian, Bulgarian, and Moldovan pigs. The breed was fattened for lard with Hungary's enormous maize crop, a large tonnage of which was exported to the UK between World Wars I and II.

Origin and Distribution

The Mangalitsa is native to Hungary and is also found in most of eastern Europe.

Hungary

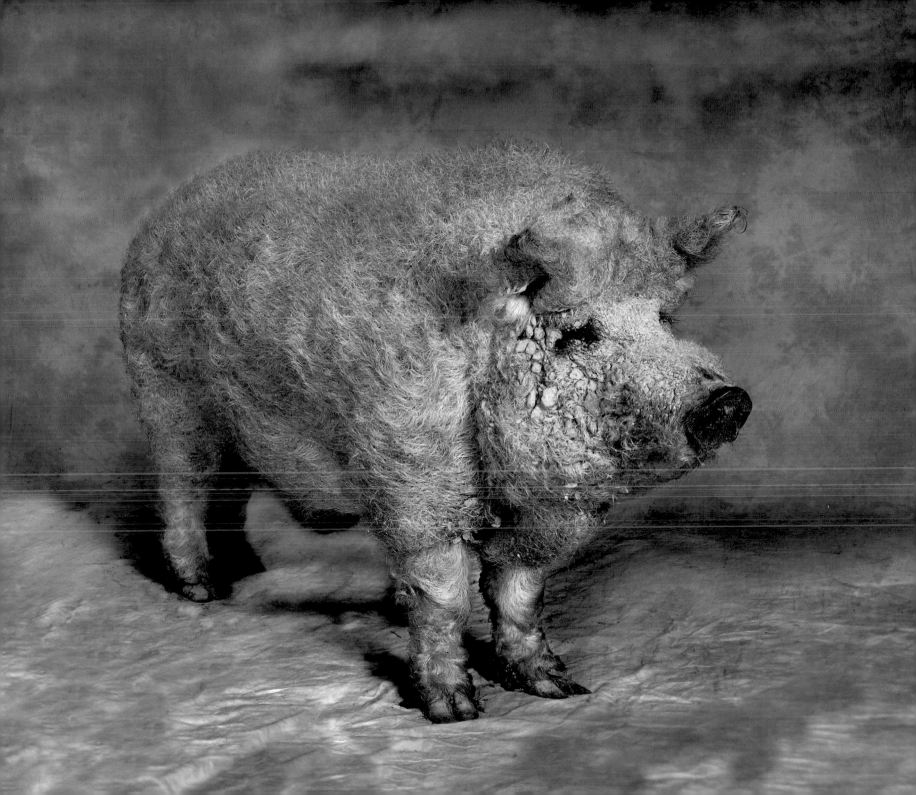

RED MANGALITSA

BOAR

The RED MANGALITSA was believed to have come about by crossing Romanian, Polish, and Yugoslavian pigs with the English Tamworth, but it is more likely to have been crossed with the Bulgarian Kula red pig. The resultant pigs went through many changes, from small and prick-eared, to the larger lard-type pig of Hungary. This type had its origins in Serbia—the reds were favored by the Austrians, where they are found in small numbers today.

Features

The Red Mangalitsa has the most uncommon color, but it is the most docile of the Mangalitsas. It has dark gray skin and black feet, but is covered in red, woolly curly hair. This enables the pig to withstand extreme weather conditions. It has good strong legs and does very well on a poor diet. Boars should have at least 10–12 teats to pass genetically to their offspring; the sows produce small litters.

Size

Boar weight 272–308 lb (123–140 kg)

Sow weight 250–285 lb (113–129 kg)

Use

The Red Mangalitsa is a late developer, but will produce a meaty carcass with a good depth of back. Back bacon, which is similar to Canadian bacon, is eaten all over eastern Europe, as is Mangalitsa salami.

Related Breeds

The mix of the Bulgarian Kula, the Yugoslavian Sumadija, and the Romanian Stocli or Baltaret, with perhaps Lincolnshire Curly Coat blood, eventually produced the Red Mangalitsa through selective breeding.

Origin and Distribution

This pig was developed in eastern Europe and favored in Austria, where it is still found; some of these pigs have recently been imported into England.

Hungary

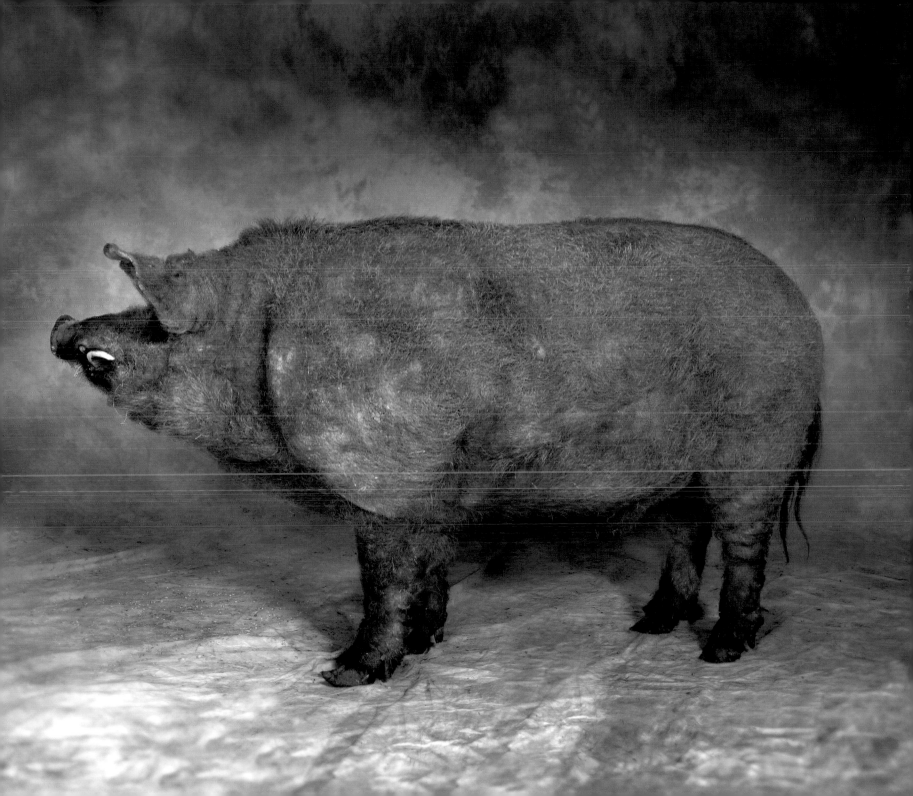

SWALLOW-BELLIED MANGALITSA

SOW

The Swallow-Bellied Mangalitsa is believed to have been created by crossing the so-called Black or Slate-Gray pig with the Black Syrmian in the south of Hungary. This gave us the slate-gray back and body of this woolly pig with its characteristic fair-colored underbelly. By selective breeding, the color was fixed. The Swallow-Belly is smaller and finer than either the Red or the Blonde.

Features

As in all the types and colors of woolly Mangalitsas, the Swallow-Belly is a contented pig and adapts to most pig-raising regimes without complaint. It has the same lopped ears, but finer bones than the Red or the Blonde, and is supported on slender legs and smaller feet. It used to be an enormous lard pig, but is now bred considerably smaller.

Size

Boar weight 250–285 lb (113–129 kg)

Sow weight 225–245 lb (102–111 kg)

Use

Still kept pure by small farmers in Hungary and surrounding countries, this pig is now mostly crossed with a commercial white pig to produce a meatier carcass with less fat.

Related Breeds

In Hungary, the Bakony was a relation of the Mangalitsa, as was the Croatian Siska and the Serbian Sumadija. It is believed that it was the Bakony pig that gave the Mangalitsa its woolly coat.

Origin and Distribution

Found in eastern Europe—more especially in Hungary in the mountains, as well in as the Great Hungarian plain—it was first exported to England in the 1990s.

Hungary

BLACK VIETNAMESE POTBELLIED
SOW

The BLACK VIETNAMESE POTBELLIED pig was developed as a dwarf pig from a Vietnamese breed in the 1960s. Originally imported into Sweden and Canada as a zoo exhibit, their use as pets began when they were taken to the United States. Suddenly, an unbelievable craze to own a pet pig started among affluent Americans; they sold for thousands of dollars, even though their temperament is questionable when they grow older, especially in the males.

Features

The original Potbellied pig was very fat and larger. It was black, had a very wrinkled face, and was swaybacked, with very short, thick legs with flattened pasterns. Now it is smaller, less fat, and has almost lost the dip in its back. The legs are finer and straighter. There are other colors now, and they are hairier—they have been bred to be more attractive.

Size

Boar weight100–120 lb (45–54 kg)

Sow weight70–100 lb (32–45 kg)

Use

If this little pig is slaughtered young enough, before it gets too fat, it can be used as a meat pig. As pets, they are nowhere near as popular as they used to be. They stand about 16 in (42 cm) high, and with their short nose are supposed to look cute. They breed only once a year and have quite large litters of tiny piglets.

Related Breeds

The Black Vietnamese Potbellied pig comes from Southeast Asia. It is thought to have Chinese ancestry because it is typical of the pigs that come from this part of the world.

Origin and Distribution

Originally from Vietnam, this breed has been taken all over the world because of the American craze for them as pets.

Vietnam

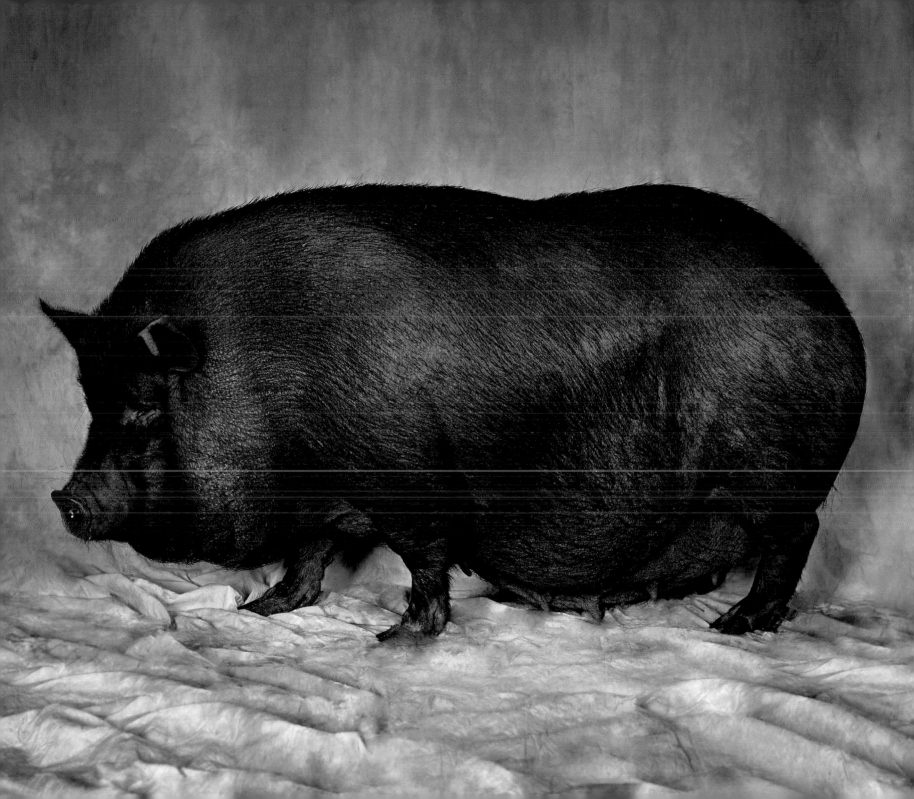

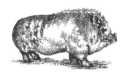

WHITE VIETNAMESE POTBELLIED

BOAR

The WHITE VIETNAMESE POTBELLIED pig is believed to have come from the northeast border of China because it looks very similar to the Mong Cai. It is believed that all potbellied pigs are descended from the ancient wild pig *Artiodactyl suina*. The Mong Cai was originally a black-and-white pig: some of these were exported to Sweden and England, and from there to Indiana, where pure white ones were bred.

Features

The White Vietnamese Potbellied pig is slightly larger than the Black. It has more hair and is also heavier boned than its cousin. The Black has very fine bones and is more swaybacked than the White, which has dark gray skin patches on its body, but with the familiar black hooves of the Black. Being less swaybacked, its belly does not sweep the ground, and it has very short, thick legs.

Size

Boar weight110–125 lb (50–57 kg)

Sow weight80–100 lb (36–45 kg)

Use

These little pigs make very good pets because they have been bred to have better temperaments than the Black Vietnamese Potbellied variety. They are programmed to farrow only once a year, and produce large litters of very small piglets.

Related Breeds

The Co from Central Vietnam is a relation, and so is the Heo Moi from South Vietnam. These two cousins are smaller than the White Vietnamese Potbellied pig, and weigh less than 110 lb (50 kg).

Origin and Distribution

It came from the northeast border of China, then spread to Sweden and England, and on to Indiana in the United States.

Northeast China

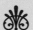

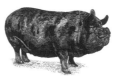

KUNEKUNE
SOW

The Kunekune, which means "fat and round," is a Maori pig from New Zealand with an uncertain history. Nobody knows quite how this little pig arrived there. The Maori say they brought them, with their pet rats for eating, from the Polynesian Islands in their canoes. This is possible, if they restrained them by their legs for the voyage. Others say the whaling ships brought them to provide fresh meat.

Features

The knee-high Kunekune is round and tubby, with a turned-up nose and dished face, and two wattles under its chin. It comes in various colors. The smallish ears can be pricked or lopped, and the boar has heavy jowls and shoulders. The body is deep and medium in length, with rounded hams and very short legs. It is very hairy and never curls its tail. It has small litters and matures late, but fattens on grass alone.

Size

Boar weight110–132 lb (50–60 kg)

Sow weight 88–110 lb (40–50 kg)

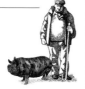

Use

The Maori kept their pigs for lard, in which they preserved their dried meat. They did not usually eat them, except when celebrating a particular event. Elsewhere, the surplus boars are turned into sausages, while the hams make succulent and tasty pork joints. The others are sold as outdoor pets.

Related Breeds

The Kunekune might have come from China. It certainly shows Chinese pig characteristics with its short nose, short legs, and tubby body. It is possible it came from Southeast Asia. New Guinea has a little pig that resembles the Kunekune.

Origin and Distribution

In 1992, the first Kunekunes were exported from New Zealand into the UK. They are now found in Ireland, France, the Netherlands, and the United States.

New Zealand

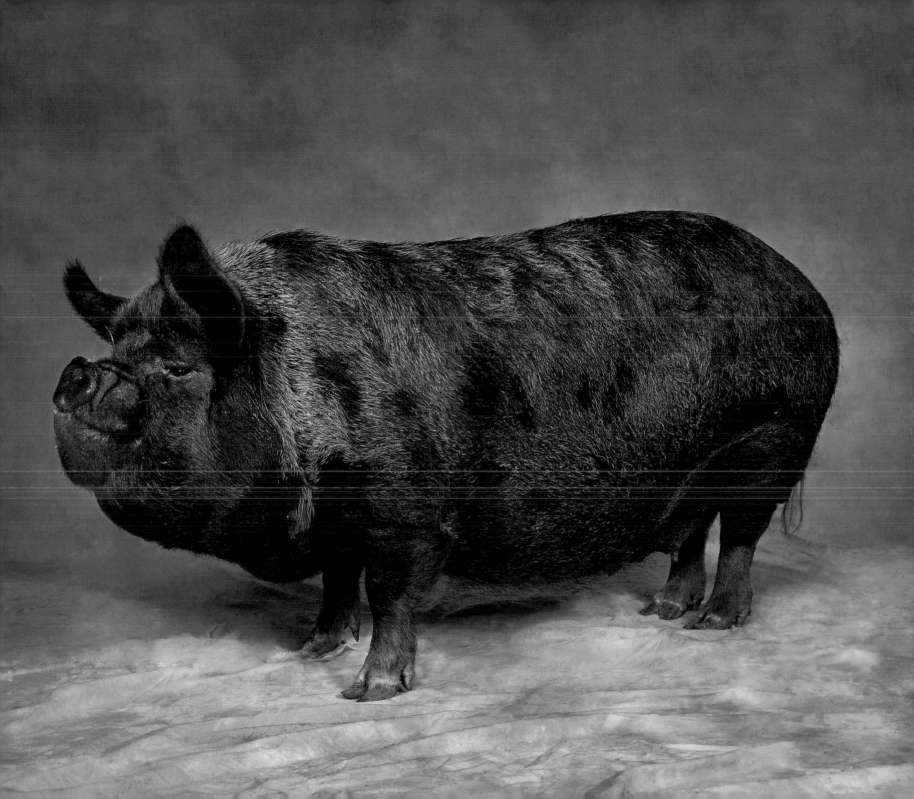

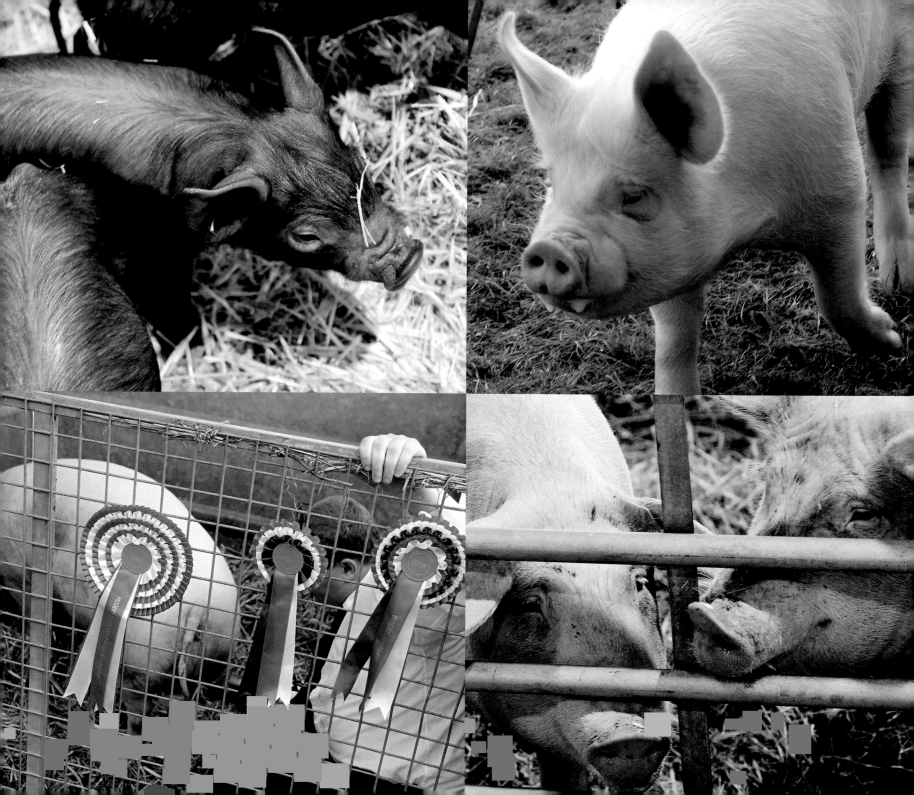

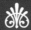

REPORTAGE

A CANDID and revealing glimpse behind the scenes at the tension, *anticipation,* and excitement that builds as our would-be PORCINE CHAMPIONS, and their proud owners, primp, preen, and prepare to step out onto the hallowed straw of the *world's leading pig shows.*

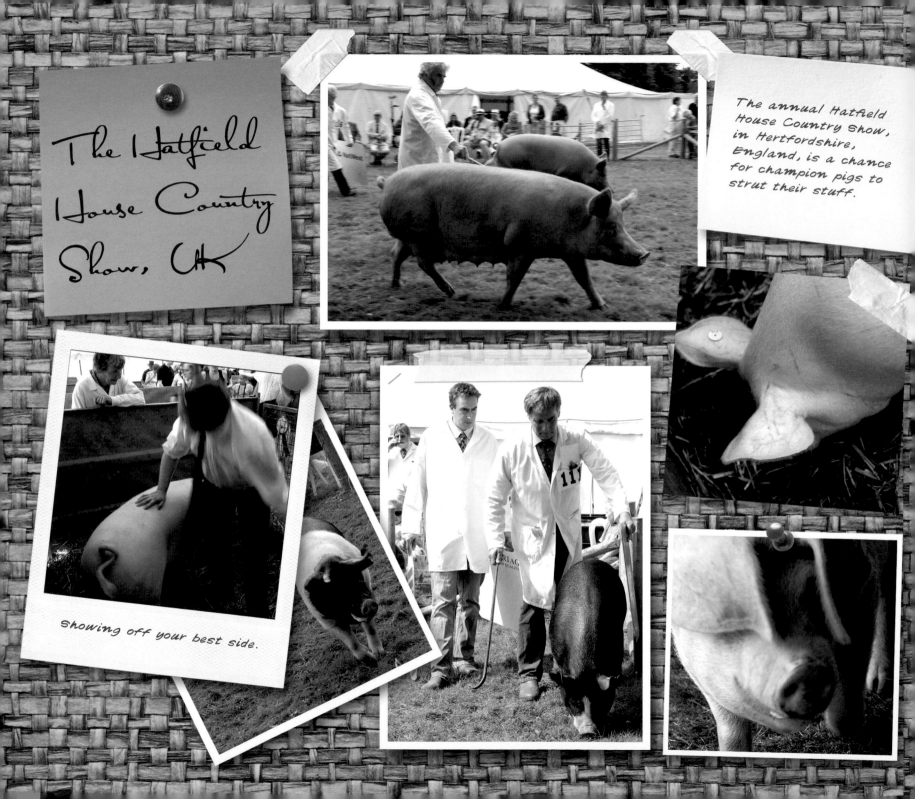

The Hatfield House Country Show, UK

The annual Hatfield House Country Show, in Hertfordshire, England, is a chance for champion pigs to strut their stuff.

Showing off your best side.

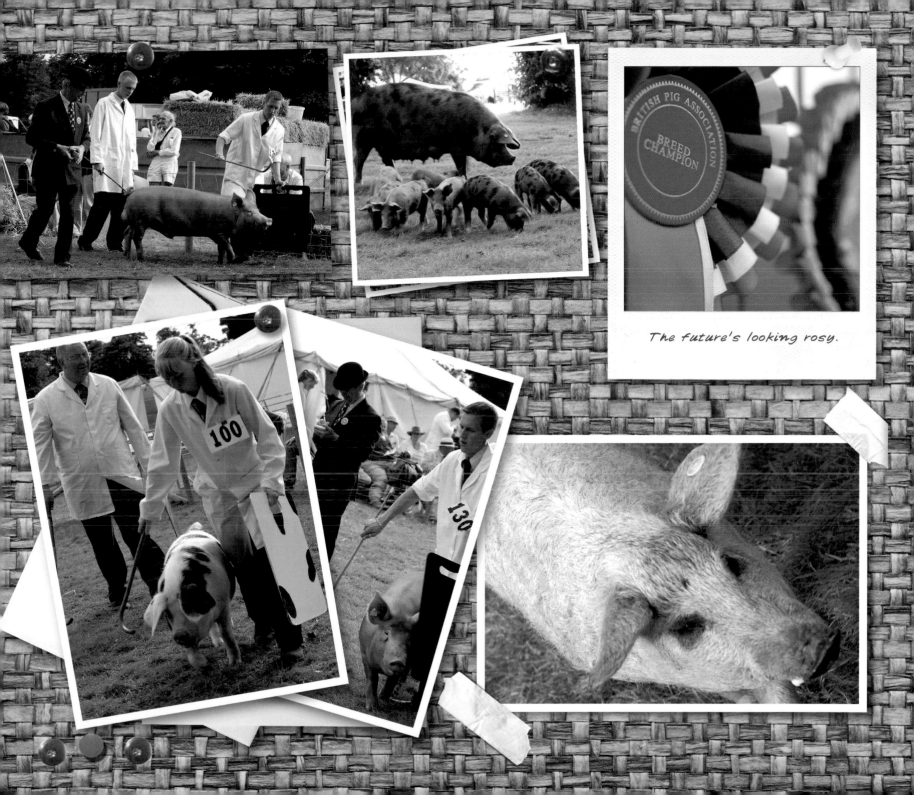

BRITISH PIG ASSOCIATION
BREED CHAMPION

The future's looking rosy.

100

130

The Hatfield House Country Show, UK

130

Which way's the VIP enclosure?

115

DIXON WILSON

D & J Norman

25

42

Pig breeders from across the United Kingdom compete for prizes. Some are luckier than others!

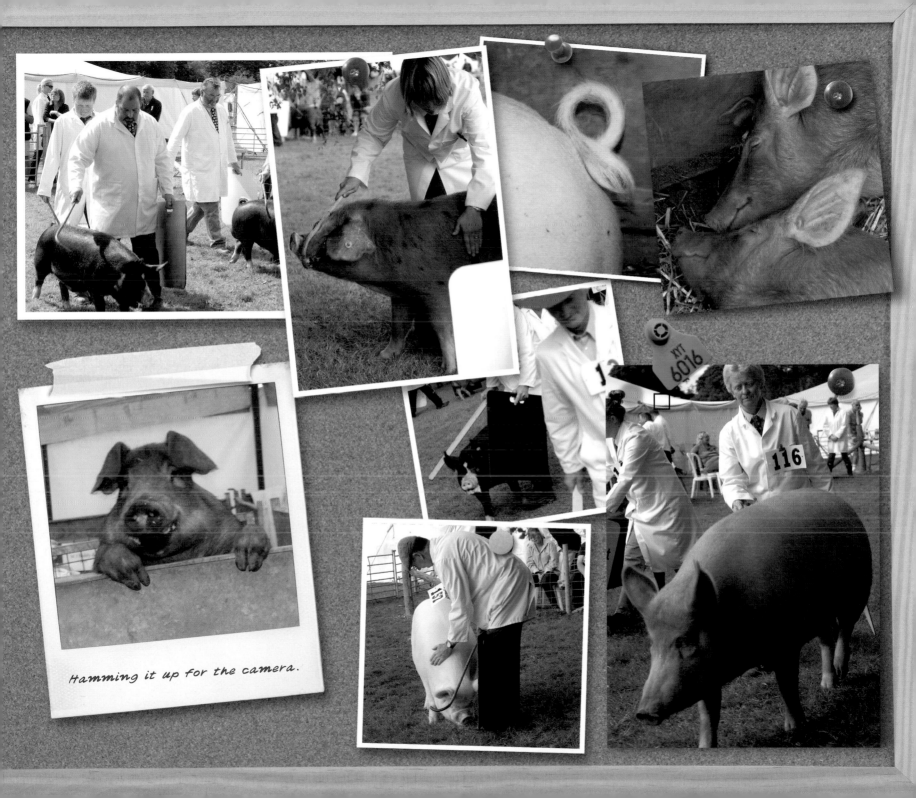

Hamming it up for the camera.

Keystone
International
Livestock Exposition,
USA

Hey, isn't that Kevin Bacon over there?

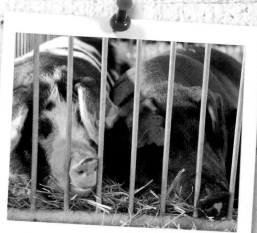

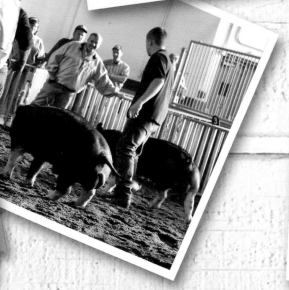

Chilling out with friends backstage.

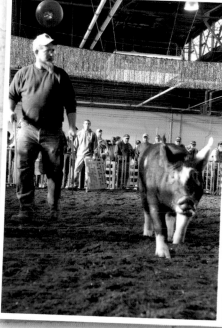

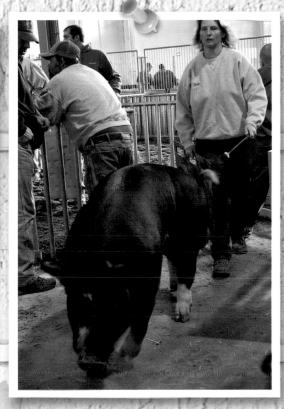

Hundreds of pigs are exhibited each year at the Keystone International Livestock Exposition in Harrisburg, Pennsylvania.

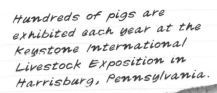

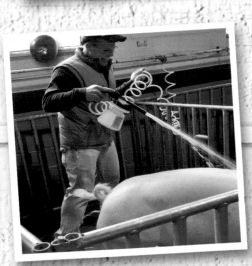

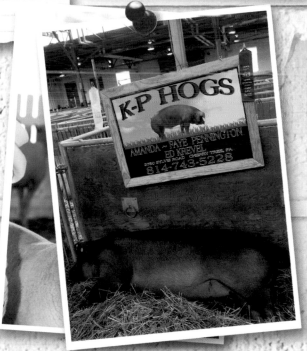

K-P HOGS
AMANDA ~ FAYE PENNINGTON
ED KREVEL
2700 SYLVIS ROAD CHERRY TREE, PA
814-743-5228

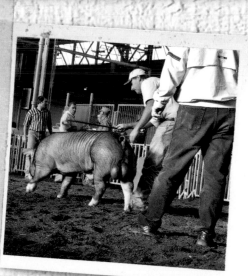

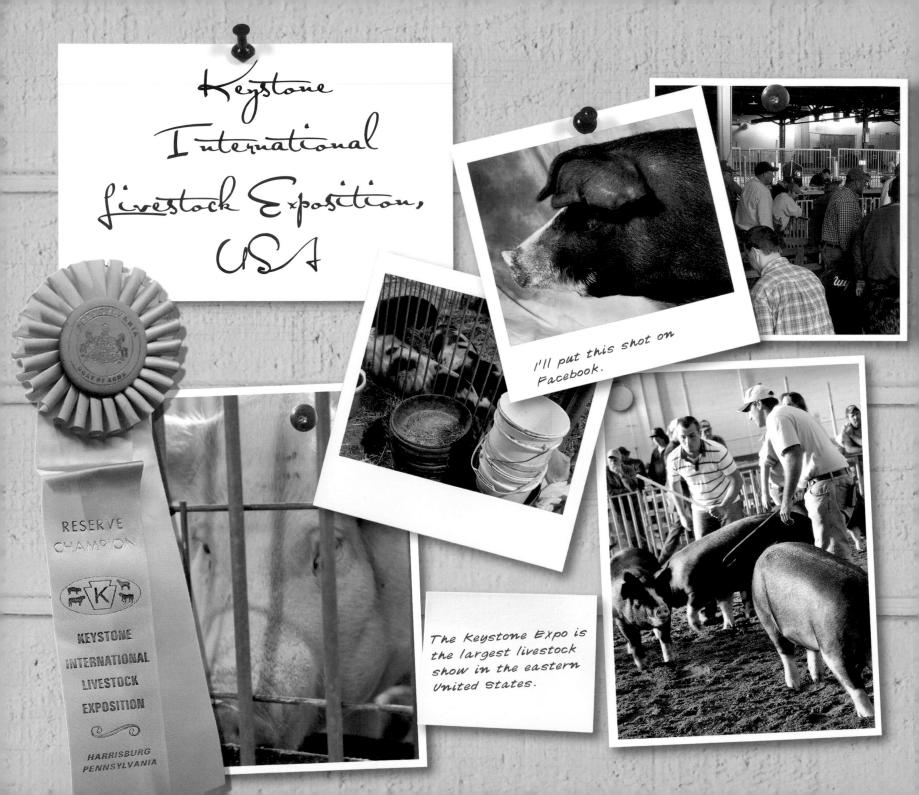

Keystone International Livestock Exposition, USA

RESERVE CHAMPION

KEYSTONE INTERNATIONAL LIVESTOCK EXPOSITION

HARRISBURG PENNSYLVANIA

I'll put this shot on Facebook.

The Keystone Expo is the largest livestock show in the eastern United States.

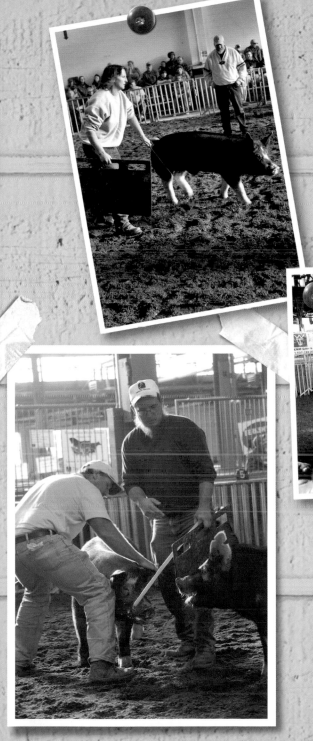

I'm a celebrity—get me out of here!

SEPOR
Pig Show,
Spain

a star is born.

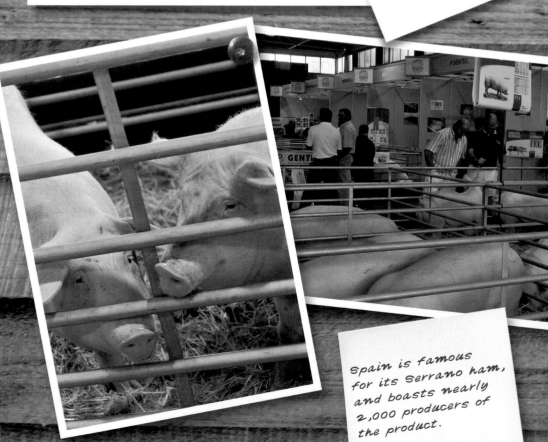

Spain is famous for its Serrano ham, and boasts nearly 2,000 producers of the product.

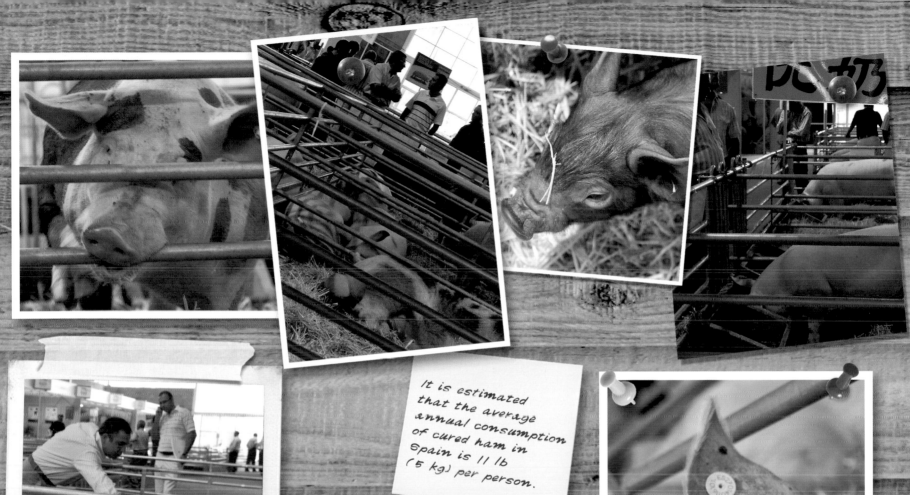

Call my agent—I can't work under these conditions!

It is estimated that the average annual consumption of cured ham in Spain is 11 lb (5 kg) per person.

SEPOR
Pig Show,
Spain

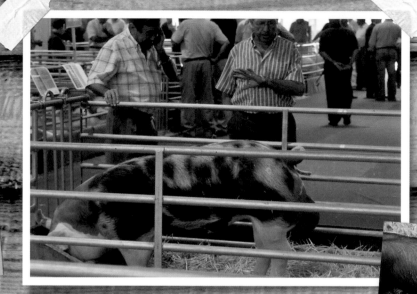

There are more than 20 million pigs on Spanish farms. No wonder competition is so fierce.

Two good reasons why I should win.

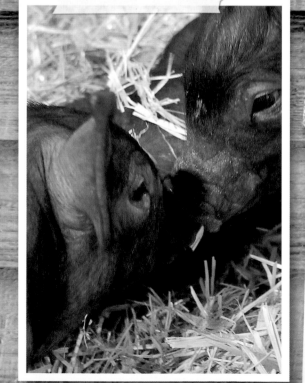

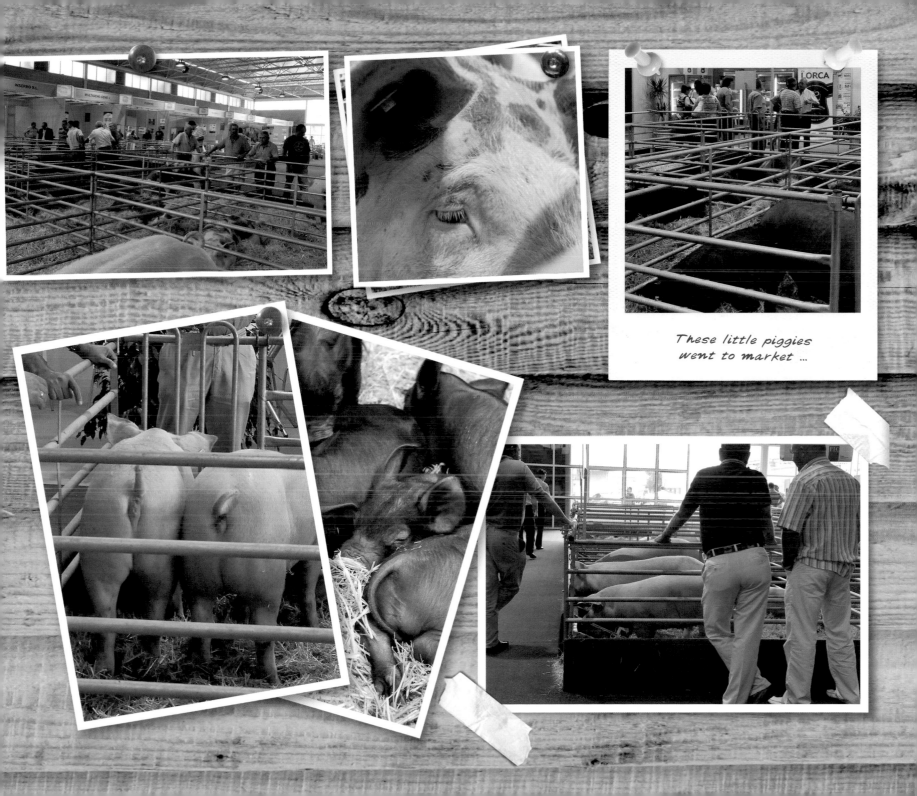

These little piggies
went to market ...

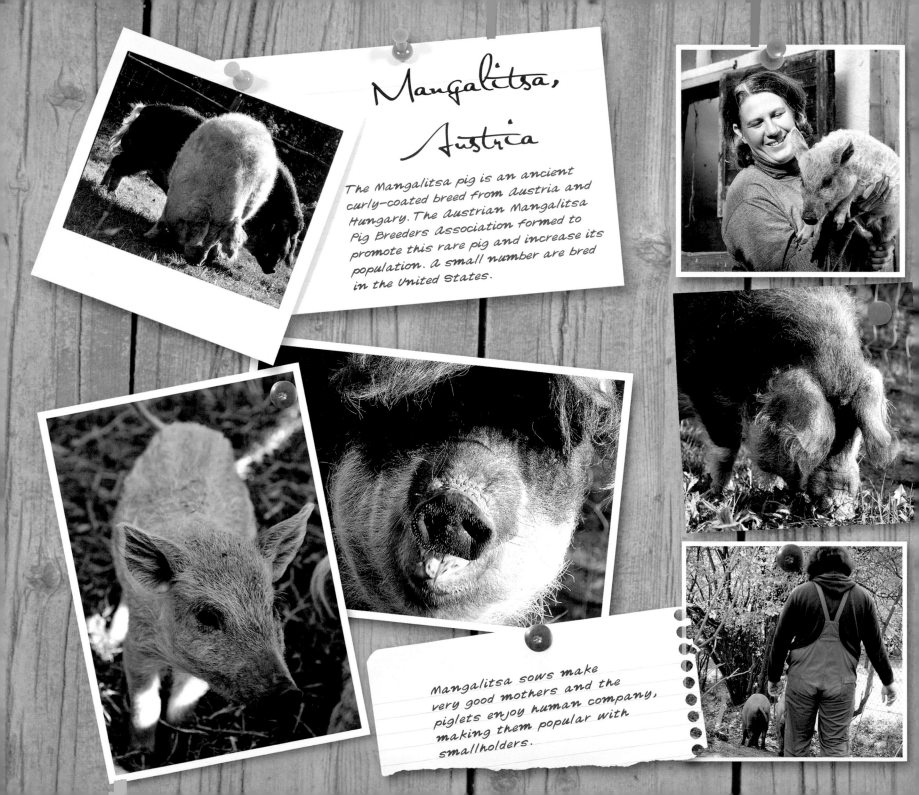

Mangalitsa, Austria

The Mangalitsa pig is an ancient curly-coated breed from Austria and Hungary. The Austrian Mangalitsa Pig Breeders Association formed to promote this rare pig and increase its population. A small number are bred in the United States.

Mangalitsa sows make very good mothers and the piglets enjoy human company, making them popular with smallholders.

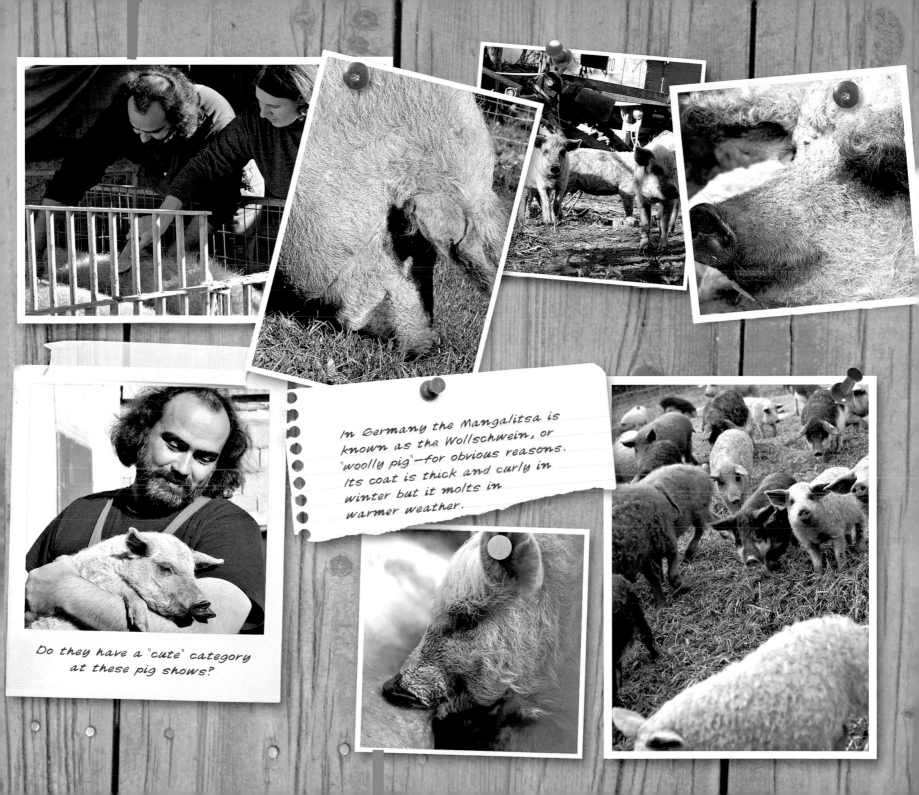

In Germany the Mangalitsa is known as the Wollschwein, or "woolly pig"—for obvious reasons. Its coat is thick and curly in winter but it molts in warmer weather.

Do they have a "cute" category at these pig shows?

GLOSSARY

Arc Pig house made of semicircular metal sheets

Action The way a pig walks

Bat A flat stick measuring about 4 ft (1.2 m) long by 2½ in (6.4 cm) wide, which is made of board and used to control a pig

Boar Male pig

Commercial pigs Pigs kept in large numbers, for profit

Conformation Configuration of the pig and body proportions

Dressing-out percentage The difference between the live weight and carcass weight

Eye muscle Round, lean meat of a loin chop

Farrowing Giving birth

Fattening pig A pig being fattened for pork or bacon

Food conversion The amount of food the pig consumes to produce a pound or kilogram of meat

Gilt Young female that has not had piglets

Hams The large muscles/meat on the backside of a pig

Herd book Official record and history of a pure breed; contains birth registrations for pedigrees

Hybrid The offspring from crossbreeding. The first-generation offspring, F1 hybrid, will have more favorable genes than their parents, and will be dominant over the less favorable

Jowl The heavy folds under the throat

Live-weight gain The amount of weight put on in a certain number of days or weeks

Lopped Ears that fall over the face and blinker the pig's sight

Modern Certain breeds are classed as such: Large White, British Landrace, Welsh, Duroc, Hampshire, and Chester White

Pastern The part of the leg between the hoof and the fetlock

Pedigree The certificate of registration showing the purebred generations of a pig

Pig board A 2-ft (60-cm) square board with a handhold cut out at the top, used to guide a pig

Points The extremities: feet, nose, and tip of tail

Porker Young pig of around 6 months old, weighing 140 lb (63.5 kg) fit to be turned into pork

Potency Virility

Rare breed A pig breed classed as at risk

Registered Certified by a pig authority to have a pedigree

Run out A pig that is run out is kept outside and allowed to forage over an area

Semilopped Ears that are inclined forward

Sheeted A colored pig that has a very large band of white around the body between contrasting colors at the front end and the back end

Slabsided A narrow pig with a prominent backbone

Sow Female pig

Terminal sire A boar used on a crossbred sow

Thrifty A pig that is economical to feed; it does not require a lot of food to put on meat

Traditional Noncommercial pigs, usually colored but not always, such as Berkshire, British Lop, Large Black, Oxford Sandy & Black, Saddleback, and Tamworth

Underline The udders of a pig or the double row of teats

Wattles The fleshy protuberances that hang down under a pig's jaw on either side

Weaners Piglets weaned off their mothers

SHOWS & ASSOCIATIONS

The following is a list of major agricultural/livestock shows and associations:

SHOWS

USA

KEYSTONE INTERNATIONAL LIVESTOCK EXHIBITION
Pennsylvania Farm Show Complex & Expo Center
2300 North Cameron Street
Harrisburg, PA 17110–9443
Web site: www.agriculture.state.pa.us/kile/site/default.asp
Telephone: 1 (717) 787–2905

THE NORTH AMERICAN LIVESTOCK EXHIBITION
937 Phillips Lane
Louisville, KY 40233–7130
Web site: www.livestockexpo.org/
Telephone: 1 (502) 595–3166
E-mail: kfecnaile@ksfb.ky.gov

Europe

THE HATFIELD HOUSE COUNTRY SHOW
Hatfield House
Hatfield, Hertfordshire
AL9 5NQ
UK
Web site: www.hatfield-house.co.uk/countryshow
Telephone: +44 (0) 1707 287010

THE ROYAL HIGHLAND SHOW
Royal Highland Centre
Ingliston, Edinburgh
EH28 8NF
UK
Web site: www.royalhighlandshow.org
Telephone: +44 (0) 131 335 6200
E-mail: showdept@rhass.org.uk

THE ROYAL SHOW
The Royal Agricultural Society of England
Stoneleigh Park, Warwickshire
CV8 2LZ
UK
Web site: www.royalshow.org.uk
Telephone: +44 (0) 2476 696 969
E-mail: membership@rase.org.uk

THE ROYAL WELSH SHOW
The Royal Welsh Agricultural Society
Llanelwedd, Builth Wells
Powys
LD2 3SY
UK
Web site: www.rwas.co.uk/en/welsh-show/
Telephone: +44 (0) 1982 553683
E-mail: requests@rwas.co.uk

SEPOR
Recinto Ferial de Lorca
Apartado de Correos 139
30800 Lorca (Murcia)
Spain
Web site: www.seporlorca.com/ing/index.asp
Telephone: +34 968 468 978
E-mail: sepor@lorca.es

New Zealand

ROYAL EASTER SHOW
Auckland Agricultural & Pastoral Association
PO Box 26014
Epsom, Auckland 3
New Zealand
Telephone: +64 9 623 7697

ASSOCIATIONS

USA

AMERICAN BERKSHIRE ASSOCIATION
Web site: www.americanberkshire.com/
Telephone: 1 (765) 497–3618
E-mail: berkshire@nationalswine.com

NATIONAL SWINE REGISTRY (USA)
Web site: www.nationalswine.com/
Telephone: 1 (765) 463–3594
E-mail: nsr@nationalswine.com

NORTH AMERICAN POTBELLIED PIG ASSOCIATION
Web site: www.petpigs.com/
Telephone: 1 (480) 266–8755

ASSOCIATIONS continued

Europe

ASOCIACION INTERPROFESIONAL DEL CERDO IBERICO (ASICI)
Apdo. de Correos 247 06300 Zafra
Badajoz
Spain
Web site: www.iberico.com/
Telephone: +34 924 554010
E-mail: iberico@iberico.com

AUSTRIAN MANGALITSA ASSOCIATION
Wischathal 20
2013 Göllersdorf, NO
Austria
Web site: www.Mangalitsa.at
E-mail: igwoe.zuchtbuch@utanet.at

BERKSHIRE PIG BREEDERS CLUB
Berkshire Pig Breeders Club
Web site: www.berkshirepigs.org.uk
E-mail: enquiries@berkshirepigs.org.uk

BRITISH KUNEKUNE PIG SOCIETY
Web site: www.britishkunekunesociety.org.uk/
Telephone: +44 (0) 1799 525421

BRITISH LOP PIG SOCIETY
Web site www.britishloppig.org.uk/
Telephone: +44 (0) 1948 880243
E-mail: secretary@britishloppig.org.uk

BRITISH PIG ASSOCIATION
Trumpington Mews
40b High Street
Trumpington
Cambridge
CB2 9LS
UK
Web site: www.britishpigs.org
Telephone: +44 (0) 1223 845096
E-mail: bpa@britishpigs.org

BRITISH SADDLEBACK BREEDERS CLUB
Dryft Cottage
South Cerney
Cirencester
Gloucestershire
GL7 5UB
UK
Web site: www.saddlebacks.org.uk/
E-mail: mail@saddlebacks.org.uk

GLOUCESTERSHIRE OLD SPOTS PIG BREEDERS CLUB
Web site: www.oldspots.org.uk/
E-mail: mail@oldspots.org.uk

LARGE BLACK BREEDERS CLUB
Web site: www.largeblackpigs.co.uk/
E-mail: kenworthyflock@fsmail.net

MIDDLE WHITE BREEDERS CLUB
Telephone: 01285 860229
E-mail: miranda@middlewhites.freeserve.co.uk

OXFORD SANDY & BLACK PIG SOCIETY
Web site www.oxfordsandypigs.co.uk/
Telephone: +44 (0) 1722 718263
E-mail: osbpigs@homecall.co.uk

THE PEDIGREE WELSH PIG SOCIETY
Telephone: +44 (0) 7966 583896
E-mail: lorni-lou@fsmail.net

TAMWORTH BREEDERS CLUB
Web site: www.tamworthbreedersclub.co.uk/
Telephone: +44 (0) 1522 778757
E-mail: secretary@tamworthbreedersclub.co.uk

New Zealand

AUCKLAND AGRICULTURAL & PASTORAL ASSOCIATION
PO Box 26014
Epsom, Auckland 3
New Zealand
Telephone: + 64 9 623 7697

Picture credits

Corbis/Historical Picture Archive:
20 TL, 20 TR, 20 BR, 25, 27, 29.
Getty Images/Dorling Kindersley: 31.
iStockphoto: 10; © Tim Burrett: 13.
Mary Evans Picture Library: 20 BL, 23.

Cover photograph **Gloucestershire Old Spots** by Paul Farnham

AUTHOR'S ACKNOWLEDGMENTS

To my wife and helpmate, Maureen, who, with me, built our pig herd up to what it is today; who really started it all by pestering me to buy her a couple of Berkshire gilts, all those years ago. I owe her so much.

I would also like to thank my dear friend Laura Henderson, who typed, edited, and printed my words in such a short time, so efficiently, so willingly, and so cheerfully. I extend my warmest thanks.

My thanks must also go to Tom Kitch and Lorraine Turner of Ivy Press: Tom for giving me the opportunity to write the words for the lovely pictures of these beautiful pigs, and Lorraine for guiding my footsteps along the way.

PUBLISHER'S ACKNOWLEDGMENTS

The publisher would like to thank all the pig associations and organizations for their assistance with this book. We would also like to express our gratitude to the pig owners and breeders for their help and cooperation in arranging the photo shoots at the agricultural shows, farms, and country estates:

American Berkshire Calvin Lazarus family
American Duroc Calvin Lazarus family
American Hampshire Calvin Lazarus family
American Landrace Calvin Lazarus family
Berkshire Charles Bull
Black Vietnamese Potbellied Paul Leven
Blonde Mangalitsa Christoph Wiesner
British Lop Mark Edgar
British Saddleback J.R. & M.L. Wreakes
Chester White Calvin Lazarus family
Chato Murciano José Reverte Navarro
Duroc Hayley Loveless
Gloucestershire Old Spots Stephen Booth
Hampshire M.J. Kiddy and son
Kunekune Andy Case
Landrace Jaime Torrento Calmet
Large Black A. W. Acreman
Large White Steve Loveless
Middle White Brian Merry
Oxford Sandy & Black Maureen and Andy Case
Piétrain Antonio Pollan Martinez
Poland China Calvin Lazarus family
Red Mangalitsa Christoph Wiesner
Spotted Swine Calvin Lazarus family
Swallow-Bellied Mangalitsa Christoph Wiesner
Tamworth Viscount Cranborne
Welsh Christine Vaughan
White Vietnamese Potbellied Paul Leven
Yorkshire Calvin Lazarus family

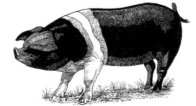

INDEX

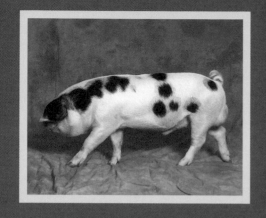 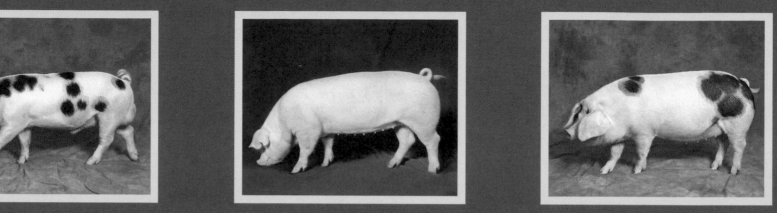 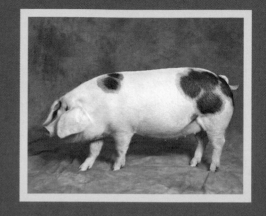

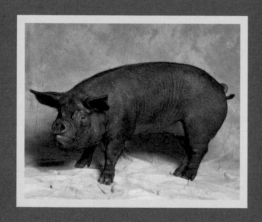 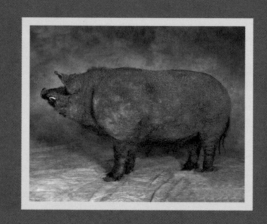 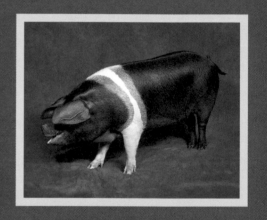

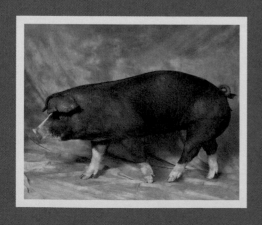 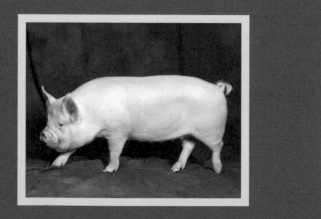 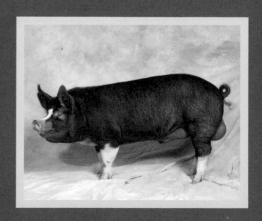